Asheville's
HISTORIC
ARCHITECTURE

RICHARD HANSLEY

THE
History
PRESS

Published by The History Press
Charleston, SC 29403
www.historypress.net

Front cover: *Springtime in Pack Square*, by Ann Vasilik.
All images are from the author's collection unless otherwise noted.

First published 2011

Manufactured in the United States

ISBN 978.1.60949.107.9

Library of Congress Cataloging-in-Publication Data
Hansley, Richard.
Asheville's historic architecture / Richard Hansley.
p. cm.
Includes bibliographical references and index.
ISBN 978-1-60949-107-9
1. Historic buildings--North Carolina--Asheville. 2. Historic districts--North Carolina-
-Asheville. 3. Architecture--North Carolina--Asheville. 4. Asheville (N.C.)--History. 5.
Asheville (N.C.)--Buildings, structures, etc. 6. Asheville (N.C.)--Biography. I. Title.
F264.A8H36 2011
975.6'88--dc22
2011007653

CONTENTS

CONTENTS

CONTENTS

CONTENTS

ACKNOWLEDGEMENTS

I n undertaking the writing and research for this book I was very fortunate in having Mitzi Tessier, Western North Carolina's foremost historian, as guide and advisor. Our many conversations were of particular joy, for her gentleness of manner and positive approach to life are truly refreshing. She is a true southern belle.

Editing credit also goes to Dan Cabaniss, associate professor of English and journalism, Gainesville State College Oconee, for his many recommendations. Thanks to William Wescott and John D. Rogers Jr. for reading the final manuscript and offering valuable insight and expertise to the final product.

In addition to *Cabins and Castles* and *Historic Architectural Resources of Downtown Asheville, North Carolina*, my major sources of architectural and historical descriptions were derived from the National Register of Historic Places and the Asheville-Buncombe Historic Resources Commission reports. If I have inadvertently utilized words or phrases directly from these professionally written guides, as I attempted to clearly paint a word picture for the reader, I do humbly apologize to these fine authors.

A special thanks to Ann Wright and Zoe Rhine, those lovely ladies at Pack Memorial Library's North Carolina Room, for their patience, knowledge and wonderful sense of humor that always made my visits one of anticipation and pleasure. Betsy Murray, also of the North Carolina Room, provided information on James Vester Miller.

Thanks to Jennifer Blevin, Cristin A. Moody and Director Stacy Merton of the Asheville-Buncombe Historic Resources Commission (HRC) and

ACKNOWLEDGEMENTS

to Becca Johnson, North Carolina Cultural Resources Department, for their willingness in making their many files available. Thanks to Martha Fullington for guidance in writing architectural descriptions.

The following individuals, with specific knowledge of particular buildings, were giving of their time in reviewing my manuscript and offering guided tours, comments and suggestions: Juanita Clark Boyd (James Vester Miller) for a delightful personal interview; Clay Griffith (City Building of Asheville); Sharon Fahrer (Montford Historic District); Reverend William Whisenhunt (Trinity Episcopal Church); Helen Wykle, Librarian Special Collection, Ramsey Library, UNCA (George Pack); Cindy Hawkins (Biltmore Building); Wayne Jewsbury (First Baptist Church); Sallie Middleton and Sallie Middleton Parker (Douglas Ellington); Reverend Howard Hanger (Hanger Hall); Cathy Sklar (Albemarle Inn); John B. Dickson (Asheville Savings Bank) for an extended tour of the facility; Peter and Lori White (Black Walnut Inn) for a guided tour; Rita and Bruce Wightman (Cedar Crest Victorian Inn); Lou Bissette and Bill Wescott (Grove Arcade); Bruce Johnson (Grove Park Inn and E.W. Grove Office Building); L.B. Jackson Jr. (Jackson Building) for his southern hospitality and access to family histories; Art Bowling (Kenilworth Apartments) for providing a tour of the facility; Jim and Linda Palmer (the Lion and the Rose) for a guided tour; Roy Harris (Mount Zion Missionary Baptist Church); Howard Stafford (Princess Anne Hotel) for a personal tour; Bob Taylor (Rumbough House) for a personal tour of the house; Vann Gibbs (Scottish Rite Cathedral and Masonic Temple) for an extended tour of this awesome building; Marge Turcot (Samuel Harrison Reed House); Aaron Hazelton (Biltmore Village Inn); Mary Alice Nard (St. Mary's Episcopal Church); Steve Hill, director (Thomas Wolfe Memorial), for time and access to his voluminous files; Barbara and Bob Gilmore (Wright Inn & Carriage House); Shirley Burden McLaughlin and Frances McDowell (Fernihurst); Harry Harrison, executive director (YMI); John Toms (the Basilica of St. Lawrence); Eula Shaw (Hopkins Chapel African Methodist Episcopal Zion Church); Dale Wayne Slusser (Ravenscroft and E.W. Grove Office Building); and Jack Thomson, executive director, the Preservation Society of Asheville and Buncombe County (E.W. Grove Office Building). Frank Thomas of the Asheville Art Museum was gracious in allowing me access to their most comprehensive library of information regarding Douglas Ellington.

INTRODUCTION

While Asheville is widely known for its temperate climate, breathtaking mountain vistas and cultural diversity, it is the elegance of its architectural heritage that is a vibrant part of the city's charm. Buildings of historical significance will both amaze and captivate you with their variations of style, intricate detailing and rich histories. Think of these buildings as the elder statesmen of Asheville—those who have lived a long and fruitful life and now stand in mute testimony to the many architects who labored to create these lasting works of art.

The possibility of seeing beauty where we had not previously looked
—Alain de Botton, The Architecture of Happiness

Architects, out of tradition and necessity, have adorned their buildings at heights far above what the normal viewing public would see. All the good stuff is above. The casual passerby is not inclined to look up to see what delights of fancy these creative artists have embellished their structures with. This book attempts to remedy that situation by bringing to the reader eye-catching details and in-depth information on Asheville's wide array of architectural styles and fascinating neighborhoods.

From the Classical to Art Deco to the Commercial style, a variety of styles awaits your viewing pleasure. The buildings and their respective neighborhoods have been grouped into geographical areas, thus allowing the reader to leisurely stroll from building to building.

Since most of the building descriptions are somewhat technical in nature, a glossary has been provided to assist you in interpreting the language of architecture. I hope that by the end of this book you will have a new appreciation and awareness for the unfolding beauty and history of our buildings and will be able to readily identify the styles and features of Asheville's architectural riches.

Asheville was incorporated in 1797 and named for Samuel Ashe, North Carolina's ninth governor. Located where the French Broad and Swannanoa Rivers flow together, the city remained an isolated village due to the lack of traversable roads. The construction of the Buncombe Turnpike or Drover's Road in 1827 opened a route from Tennessee through Asheville to the coast of South Carolina, facilitating the movement of commerce. However, it wasn't until the coming of the railroad in 1880 and the construction of Frank Coxe's ultra-modern Battery Park Hotel in 1886 that Asheville quickly became a popular tourist destination for affluent travelers. An up-and-coming population infused new energy into the city that quickly attracted an innovative and progressive company of architects. George Vanderbilt's wondrous 250-room French Renaissance mansion, built in the late 1800s, attracted wide attention and brought to Asheville such notable artists as Richard Morris Hunt, the building's architect; its landscape architect, Frederick Law Olmsted; Rafael Guastavino, who would remain to construct the glorious Basilica of St. Lawrence; and Richard Sharp Smith, whose hundreds of commercial and residential buildings still adorn Western North Carolina. Each was to leave a lasting legacy for decades to come.

At the beginning of the 1900s, Edwin Wiley Grove, the patent medicine mogul, invested in land north of Asheville to create the Grove Park neighborhood, followed by his Grove Park Inn in 1913, the new Battery Park Hotel in 1923 and the Grove Arcade in 1929.

In the 1920s, there was a frenzy of buying and selling that captivated the city. Fortunes were made and lost in a single day. Many claim that the construction of Grove's Battery Park Hotel and L.B. Jackson's multistory Gothic structure was the spark that ignited the rush for land acquisition. From 1920 to 1930, over sixty notable structures were erected in the downtown area alone. In addition to those covered in this book there were the Bon Marche department store, built for Solomon Lipinsky by E.W. Grove (Haywood Park Hotel and Promenade); the George Vanderbilt Hotel (Vanderbilt Arms); the New Medical Building on Market Street; the Asheville-Biltmore Hotel (Altamont Apartments); and four automobile showrooms on Coxe Avenue.

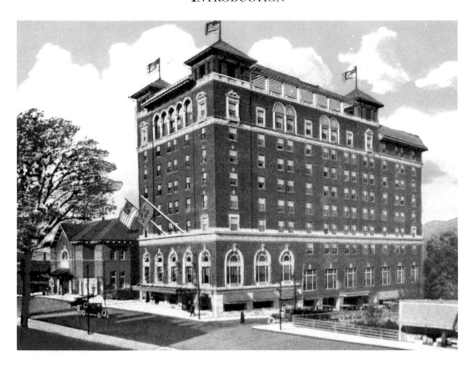

George Vanderbilt Hotel. *Courtesy of the North Carolina Collection, Pack Memorial Public Library, Asheville, North Carolina.*

With the issuance of bonds in 1925, the City of Asheville initiated a municipal building program that included a new City Building, a new Buncombe County Courthouse, a new golf course, Asheville High School, a tunnel through Beaucatcher Mountain, numerous parks and a new football stadium. Incorporated into this period was the cutting-edge architecture of Douglas Ellington, whose First Baptist Church, City Hall, Asheville High School and S&W Cafeteria remain as monuments to his architectural genius. Much of the downtown area's attraction can be attributed to these many fine buildings, but much of its character can also be found in numerous structures that were built in the latter part of the 1800s. Such is their prominence that we have included four of them in this book.

Although the Great Depression greatly limited new construction, Asheville saw the erection of two buildings during that time: Anthony Lord's 1939 design for the *Asheville Citizen-Times* newspaper building and Henry Gaines's 1940 Coca-Cola building on Biltmore Avenue, which is now a part of Mission Hospitals. The beautifully detailed Art Moderne interior remains intact, but the building's original façade has been replaced. A stylish Art

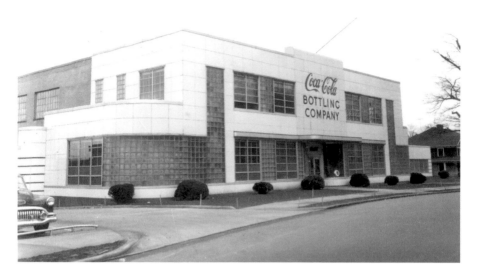

Coca-Cola Building. *Courtesy of the North Carolina Collection, Pack Memorial Public Library, Asheville, North Carolina.*

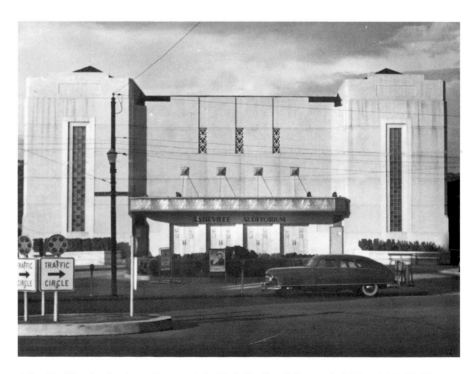

Asheville City Auditorium. *Courtesy of the North Carolina Collection, Pack Memorial Public Library, Asheville, North Carolina.*

Deco city auditorium was built in 1939 by the federal government's Works Progress Administration; remnants of the auditorium can be seen within the confines of the new civic center.

From the Great Depression through World War II, building construction in Asheville was at a minimum and remained fairly static up into the 1960s. The multistory Northwestern Bank building (BB&T) opened in the middle sixties, and a bond issue was passed for construction of a new civic center that was completed in 1974. In 1976, a cut through Beaucatcher Mountain opened the way for the I-240 expressway to all points east. In the late 1970s, several commercial buildings on the north side of Pack Square were demolished to make way for I.M. Pei's Akzona Building (the Biltmore Building). Bele Chere inaugurated its first street festival in 1979, and the downtown area was placed on the National Register of Historic Places. In that same year, the Imperial Theater on Patton Avenue, which had been a mainstay of theatergoers since 1922, was demolished. From Church Street to Lexington Avenue, all the buildings on the south side of Patton Avenue were razed to make way for a parking lot. In the 1990s, McCormick Field, home of the Asheville Tourists professional baseball team, was remodeled; Pack Place Education Arts & Sciences Center opened; a new federal building was built on Patton Avenue; St. Joseph's and Memorial Mission Hospital merged to become Mission Hospitals; Asheville became an All-American city; and the Thomas Wolfe Visitor Center on North Market Street opened. In 2002, the Grove Arcade reopened after extensive renovation, and in 2006, the Asheville Chamber of Commerce relocated from Haywood Street to a new multistory building at the corner of Montford Avenue and Hill Street.

Much of downtown is being transformed with the rehabilitation of older buildings into apartment/condominiums and the erection of new multistory hotels. While these new additions provide needed accommodations for the many visitors attracted to our one-of-a-kind-city seeking healthy mountain air and glorious vistas, it is the architecture that will be remembered long after all else has been forgotten.

My wish is that you will never see a building in the same way again.

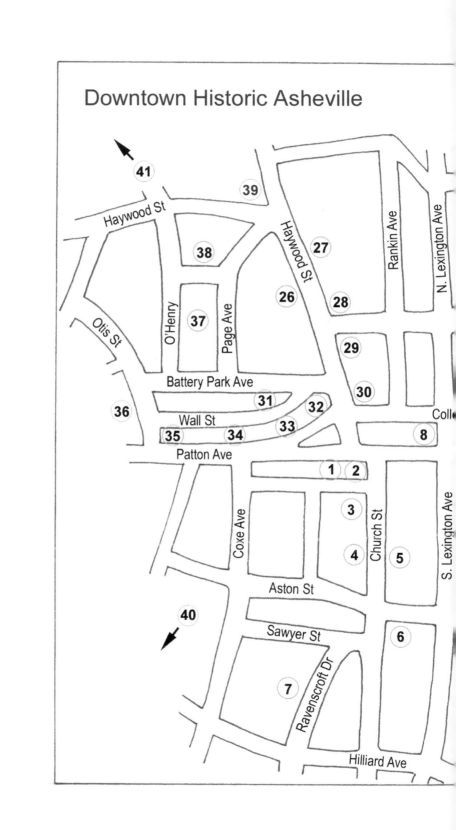

Downtown Historic Asheville

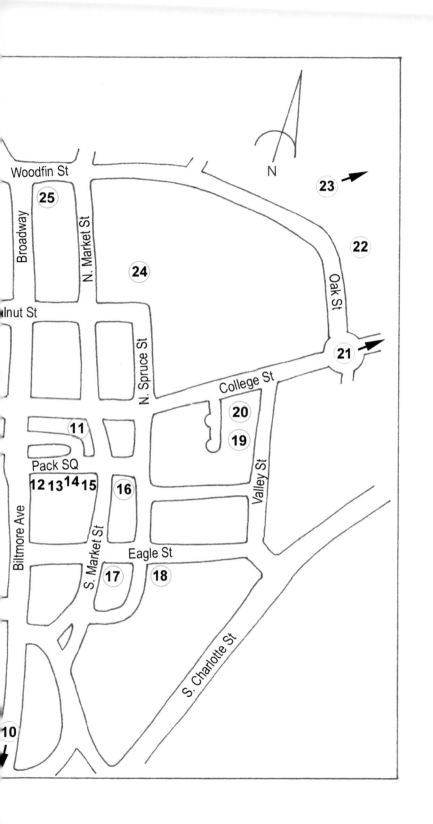

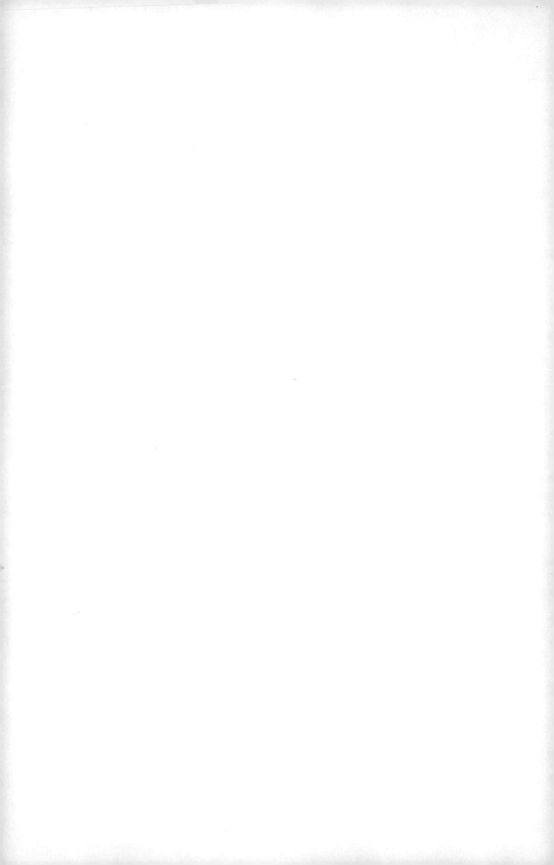

Downtown Historic District

Numbers preceding each title refer to map locations

1. S&W Cafeteria

One of the finest examples of Art Deco styling in North Carolina, the S&W Cafeteria, built in 1929, is located at the intersection of Haywood Street and Patton Avenue. Architect Douglas Ellington's design is dazzling with its brilliant use of polychrome gold, black, cream, blue and gilt-glazed terra cotta, embodied in various geometric shapes and floral motifs. The building is constructed of gray ashlar stone on a black base and consists of an asymmetrical but balanced design in which the main entrance, framed by two large arched windows, constitutes two-thirds of the front; the remaining third, set off by a pilaster, contains a large rectangular window with concave corners inset with frets.

The arched windows, rising into the second floor, contain voussoirs of flat panels divided by gold strips and surrounded by blue-gray chevron sections, terminating in fretwork.

Over the main entrance, Ellington placed a stylized fountain within an octagonal opening, adding fretwork, and the company sign. Stylized artwork depicting various fruits completes the design. Classical designs of stylized fountains in gold on a black background divide the second-story ribbon windows. A horizontal band of gray chevrons, divided by stylized triglyphs, defines the window tops.

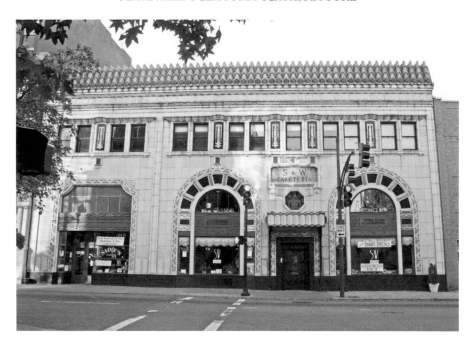

The frieze/cornice area is a combination of square blocks sandwiched between continuous rows of chevrons. The roof is composed of blue terra cotta tiles stacked three to a strip.

Asheville's S&W Cafeteria opened in 1922 in a leased building on Patton Avenue, making it the third North Carolina cafeteria started by Frank O. Sherrill and Fred R. Webber. By 1929, having outgrown the leased property, Sherrill, who had acquired sole interest in the company, hired Ellington to design a building exclusively for use as a cafeteria. The business remained in this building until 1974, when it moved to the newly opened Asheville Mall.

The building was placed on the National Register of Historic Places in 1977.

2. DRHUMOR BUILDING

The Drhumor Building, located at the corner of Patton Avenue and Church Street, is one of the finest examples of Romanesque Revival architecture in Western North Carolina. William Johnston Cocke, grandson of William Johnston, a wealthy real estate entrepreneur, desired to build a large commercial structure on land left to him and his relatives. The result

is a four-story brick building designed by Allen L. Melton (1852–1917) and completed in 1896. The façade features segmental arched windows of rock-faced limestone indicative of the Romanesque style. The name Drhumor (dru-MOOR) came from the Johnson family's ancestral home in Ireland.

Originally built as a retail and office building, it was purchased by Wachovia Bank in 1929. The original entrance, located at the corner, was subsequently filled in, and a new entrance was located on Patton Avenue. The new entrance is a two-story Roman arch surrounded by a molding of twisted strands called cable or rope molding. Above the arch are facing griffins bordered by ornamental bands of undulating plant motifs commonly referred to as rinceau.

The outstanding feature of the building is the frieze and capitals created by sculptor Fred Miles. The frieze is supported by pairs of engaged columns on piers and capitals of ornamental Byzantine foliate. The frieze is decorated with relief carvings of British royal lions, faces of men and women, cupid-like children and other intricate foliate designs. Also shown are angels, seashells, mermaids and other mythological figures. Noteworthy is the distinctive brick corbelling along the cornice line.

In 1970, the building was sold to the First Citizens Bank of Asheville and then, in 1992, was sold to Drhumor Associates and Pritchard Park, LLC.

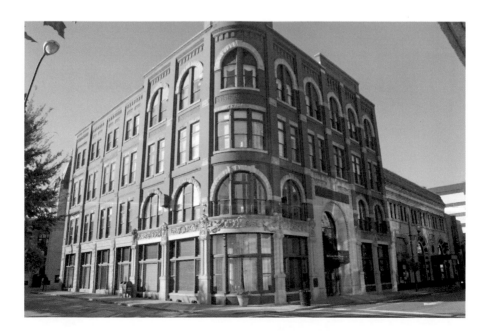

The style of architecture called Romanesque Revival, also known as Richardsonian Romanesque, was made famous by Henry Hobson Richardson (1838–1886) and became popular from 1880 to 1900. This style was chiefly used in public buildings, such as churches, courthouses, libraries, railroad stations and universities, due to its massive appearance. It was usually composed of a façade of dark, rock-faced masonry, rough cut to emphasize its texture, and occasionally in combination with brick. Notable among Richardson's buildings are the Trinity Church in Boston, Massachusetts; the Crane Library in Quincy, Massachusetts; and the Allegheny County Courthouse in Pittsburgh, Pennsylvania. Richardson's longtime friend Frederick Law Olmsted frequently worked with him as his landscape architect.

3. Asheville Savings Bank

Just a few steps from Patton Avenue down Church Street, the splendor of classical architecture rises in the form of the Asheville Savings Bank building. Originally composed of three buildings that were combined by architect Ronald Greene in 1922, the new structure managed to evoke the look of ancient Greece in Asheville. The northern and central buildings were combined into one façade, while the southern portion retained the original brick. A major renovation in 1965 obscured much of the building's classical appearance, and it was not until 2005 that the building was restored to its original design.

The majestic two-story corner entrance has flanking Tuscan concrete columns, while overhead a classic Doric Roman entablature with triglyphs, metopes, guttae and dentil molding completes the classical style.

The wall treatment, on portions of the Church Street and Commerce Street side, is a concrete veneer fashioned to simulate stone. The lower section of the wall on Commerce Street is composed of stucco with faux lines to simulate ashlar block.

The southern brick portion of the building, facing Church Street, has a marvelous over-door design of parquet and Flemish bond brickwork. The brick wall facing Central United Methodist Church is finished in an American bond brickwork pattern. The cornice area is composed of a continuous row of brick arches situated below a decorative frieze. A corbelled layer of mutules above the frieze completes the wall treatment.

Ronald Greene's architectural career left a lasting mark on Asheville, as described by historian Sybil Bowers:

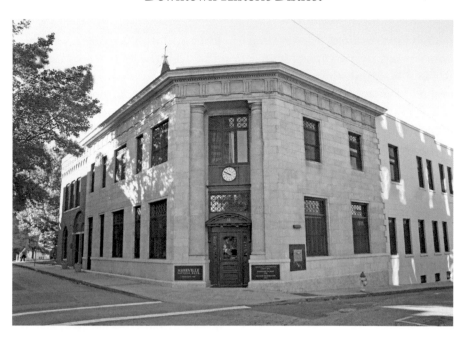

Ronald Greene, architect for the 1922 remodeling of the [Asheville Savings Bank] *building, was a prominent architect in Asheville, completing most of his commissions in the area in the thriving 1920s. Born in Coldwater, Michigan in 1891, he was educated at the Pratt School of Architecture, Columbia University, and the Beaux Arts Atelier of Cleveland. He came to Asheville in 1916, designing many buildings in the city, including Stephens-Lee High School (1921); Claxton Elementary School (1922); the Jackson Building (1923–24); the Westall Building (1925); the Municipal Building (1925–26); the Longchamps Apartments (1925); and the Annie J. Reed House (68 Kenilworth Road, 1948). Throughout his career, Greene was associated with Robert L. Kane, Stewart Rogers, and with the firm of Green and Robelot of Asheville and Knoxville. Greene moved in 1951 to Gastonia N.C. where he lived until his death in 1961.*

4. CENTRAL UNITED METHODIST CHURCH

The third Methodist Church building to occupy this same site on Church Street is a monumental tribute to the Romanesque style of architecture. Built from 1902 to 1905 and constructed of rock-faced limestone, the

church features an arcaded entrance in front of the gable-roofed sanctuary and flanked by two massive towers topped by dormers and pinnacles. Reuben H. Hunt, the architect, chose to deviate from the normal round arched windows, typical of the Romanesque style, to adorn the building with Gothic detailing, including pointed Gothic windows, thus giving the church its own distinctive style. In charge of original construction was J.M. Westall, the younger brother of Thomas Wolfe's mother, Julia Westall Wolfe.

Church membership rose to two thousand in 1924, necessitating additions to the existing building. Following Hunt's design, a three-story Sunday school building was added to the southern end of the structure. The first floor, utilized for a men's Bible class, included a theatrical stage, with a fully furnished kitchen to the rear. Sunday school rooms were located on the second and third floors, which now house church administrative offices. At the same time, the sanctuary was expanded thirty feet to the rear, and a much-needed balcony, seating several hundred, was added. In 1967, a new three-story Sunday school building was added to the south side of the Fellowship Hall.

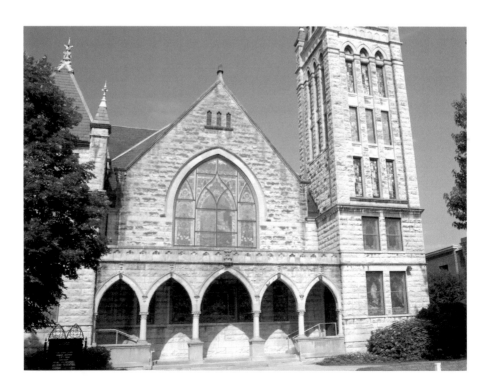

Hunt (1862–1937) was a prominent regional architect based in Chattanooga, Tennessee. Known as the "Master Builder of Chattanooga," his company specialized in churches and public buildings mainly in the medieval and classical styles. By producing his own pattern book of church designs, he was able to market his style over a large regional territory. Pattern book illustrations included a plan drawing, a perspective and a cost estimate, making it a simple matter for church congregations to make an educated decision regarding the type of church they wanted to build.

5. FIRST PRESBYTERIAN CHURCH

Formed in 1794, the congregation of the First Presbyterian Church of Asheville has the distinction of being one of the city's earliest religious organizations, and its church building is one of Asheville's oldest as well. Completed in 1885 in the traditional Gothic Revival style, prominent at

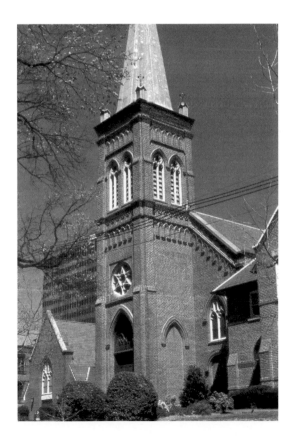

that time, the church has an imposing tower that includes corner buttresses, brick corbelling and an imposing copper spire. A rose window with star-shaped tracery highlights the tower entrance. The brickwork is done in the American bond pattern. Additional features of the church include blind-arcaded brickwork at the eaves and hood-molded windows

Over the years, the church has undergone numerous renovations. The sixth set of renovations occurred in 1915, when William J. East designed changes that enlarged the sanctuary and Sunday school rooms. In 1951, under the direction of architect Anthony Lord, the 120-foot steeple was re-covered in copper, and the sanctuary underwent a complete renovation. A new slate roof was added at this time. The next major remodeling came in 1968, when a new chapel and education wing were added under the guidance of architect J. Bertram King.

In 2003, the architectural firm of Rogers Associates completed a large remodeling project for the church. Included in the project were additional administrative office space, a parking deck, a reconfigured parking lot, two atriums and a weekday entrance on Aston Street.

6. Trinity Episcopal Church

A monumental example of the Gothic Revival style of church architecture, Trinity Episcopal Church, built in 1913 on the corner of Church and Aston Streets, was the third church to occupy this site. Constructed of red brick in a stretcher bond pattern, the gabled belfry and its adjacent gable-roofed sanctuary dominate the corner entrance. The stone foundation on Church Street was retained from the second church building that was otherwise destroyed by a fire in 1910. The building's granite trim and window tracery embody architect Bertram Goodhue's attention to Gothic detail. William H. Lord, a local Asheville architect, supervised construction and, in 1921, was the architect for the addition of a two-story parish hall.

In 1961, a major expansion included a larger parish hall and a three-story parish house that contained classrooms, offices and space for choir rehearsals. Constructed of brick in the stretcher bond pattern with window and door surrounds of Indiana limestone, the English Gothic–style structures were the creation of local architect T. Edmund Witmire and consulting architect Philip H. Froman, who previously worked as an architect on the Washington Cathedral. Landscape was under the direction of Doan Ogden. The church

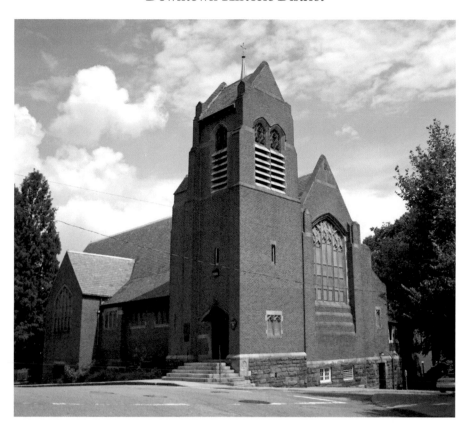

property is bordered on the north by a wrought-iron fence pierced by two Italian-style double-leaf gates.

Goodhue (1869–1924) was one of New York's most influential architects. As part of the firm of Cram, Goodhue and Ferguson, he was instrumental in the group's first major design—additions to the United States Military Academy at West Point (1901–10). Over the next two decades, the firm designed a number of major churches, all in the Gothic Revival style, including St. Thomas (1913) and St. Bartholomew (1914–19) in New York, Rockefeller Chapel at the University of Chicago (1925) and the National Academy of Sciences Building in Washington, D.C. (1924).

According to historian Carolyn Humphries:

> *In 1910, Goodhue was considered one of the nation's leading church architects and was a foremost proponent of the Eclectic Gothic style. The Gothic Revival architectural style had reached America from England about a century earlier. It was an asymmetrical, heavily detailed style, which*

relied on the design of medieval buildings. It became popular especially for Anglican and Episcopal Church buildings in the 1830s and 1840s. Church leaders, both clergy and lay, felt that the gothic church design represented the spiritual and daily activities of people of the Middle Ages whose entire lives were spent within the shadow of a great cathedral in their village, the construction of which united their physical and spiritual lives.

7. RAVENSCROFT

The oldest building in downtown Asheville, constructed in the 1840s, is located at 29 Ravenscroft Drive. It is an American bond brick building composed of two two-story gabled wings and a three-story pyramidal-roofed tower. The building's architectural style is similar to a design (Design IX) found in Andrew Jackson Downing's 1842 book, *Cottage Residences*, which classified the design in the Italian style.

From 1825 to 1864, Greek Revival architecture was popular in the United States due to Greece's fight for independence. In keeping with this trend, an unknown architect modified the design by adding an entablature on the tower and each of the gable wings, thus giving the house its distinctive Greek Revival style.

The main entrance, recessed under a balustraded square-columned porch, contains a multi-light transom, sidelights and engaged columns. The porch entablature, with triglyphs, metopes and antae, mirrors the classical details found throughout the building. The tower features second- and third-floor triple window units, with the lintel of the top unit slightly arched. Windows in each of the gable sections are double-hung, with six-over-six lights and limestone lintels and sills. In the early 1900s, the south wing and front porch were added.

Reverend Jarvis Buxton opened Ravenscroft Institute as an Episcopal Boys Classical and Theological School in 1856. Named for John Stark Ravenscroft, the first bishop of the North Carolina Diocese of the Protestant Episcopal Church, the school closed during the Civil War but eventually reopened as a theological school, then as a preparatory boarding school and, at the turn of the century, as a rooming house. It is now an office building.

The building was restored and placed on the National Register of Historic Places in 1978.

8. Kress Building

In 1927, the S.H. Kress Company, under the guidance of its staff architect, E.J.T. Hoffman, erected a four-story Renaissance-style glazed terra cotta and tan brick five-and-dime store in Asheville.

The building is bounded on three sides by Patton Avenue, Lexington Avenue and College Street. The main façade of terra cotta faces Patton Avenue and is three bays wide. A border of orange and blue rosettes and other floral motifs surrounds each bay. The uppermost corners of these borders contain a fleur-de-lis inscribed within a shield. The space between the windows—called a spandrel—has the same rectangular border with associated floral motifs.

At each entrance, a mosaic of the Kress logo is embedded in the marble floor. Curved entrance windows, a distinct feature of Kress storefront designs, are used to entice the customer into the store. A belt course over the first floor carries across the front of the building and partially down the Lexington side. The frieze, cornice and parapet carry around three sides of the building. The frieze contains a row of dentil molding, below which orange and blue circular rosettes are spaced. The front parapet carries the Kress sign within a pediment frame, with four urns completing the design. The richly detailed belt course and cornice contain various moldings such as bead and reel, heart and dart and egg and arrow.

The Lexington Avenue side is broken up into one-third terra cotta and two-thirds tan brick. Brick pilasters in Flemish bond courses divide the brick portion into four bays. The spandrels between the windows have rectangular patterns of Flemish bond brickwork surrounded by running bond courses. The brick is dotted throughout with the familiar orange and blue rosette pattern. The slope of the lot carries down to College Street, exposing portions of the ashlar granite basement and opening a richly ornamented entrance on College Street.

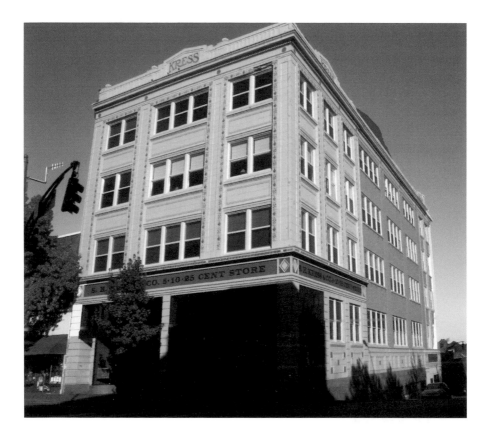

Samuel Henry Kress opened his first store in 1896 in Memphis, Tennessee. The company eventually grew to over three hundred stores, based on its philosophy of providing customers with quality merchandise at the lowest possible cost. From 1905 until the mid-1940s, Kress had its own architectural division. The Kress logo, the name on an arch, was developed in the mid-1900s and is prominent on every building at the top and on the entrance

floor. Starting in the early 1930s, Kress adopted the Art Deco style for its buildings, adding detailing that recognized regional differences.

In 1963, Genesco bought out Kress, and the company name was eliminated in 1980. Throughout the United States, Kress buildings, reminiscent of another era, are being refurbished and developed into retail stores, offices and residences.

The building in Asheville now houses the Kress Emporium on the ground floor, with condominiums added above.

9. PACK SQUARE GROUP

Nestled in the southwest corner of Pack Square are four architectural delights reminiscent of another era. The buildings that compose this corner area, constructed in the late 1800s, are all unique in style and character, exemplifying the current architectural styles for that time period. The casual visitor to Asheville during this era would have had to admit that it was an up-and-coming town, with a new courthouse being built in 1876, the main street macadamized in 1879, train travel available in 1880, a new water system constructed in 1884, the first telephone lines installed in 1885, the new Battery Park Hotel opening in 1886, electric streetlights installed in 1888 and the first electric streetcar in the state beginning operation in 1889. Truly, Asheville had arrived.

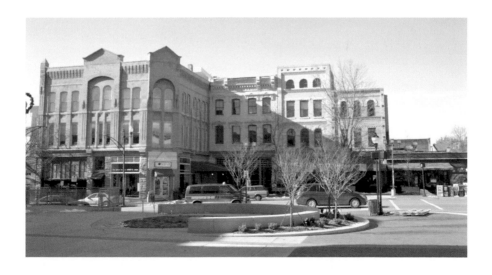

No. One Biltmore Avenue, built around 1887, is an imposing three-story, painted brick commercial structure. Gabled parapets highlight the corner and central bays sandwiched between projecting corbelled cornices. Third-level window arches vary from round to segmental, while rectangular sashes highlight the second level. All the windows are one-over-one double-hung, with stone lintels and sills; spandrels are recessed and corbelled. First-floor piers are quarry-faced sandstone.

No. 9 Pack Square, built around 1890, is a three-story Italianate building; its upper two stories were originally part of the Western Hotel that occupied 1 Biltmore Avenue. The highly decorated corbelled sheet-metal cornice contains modillion blocks, pedimented window hoods and segmentally arched two-over-two windows.

No. 7 Pack Square is a four-story, three-bay Romanesque Revival building constructed around 1890. Second-floor windows are Roman arched with rock-faced voussoirs, while the third-floor windows have a continuous rock-faced lintel. Corbelled brick stringcourses highlight the third and fourth levels.

No. 5 Pack Square, built around 1890, is a three-story painted brick Romanesque Revival commercial building. Round arched windows on the third floor contain hood moldings of brick voussoirs terminating in terra cotta blocks. The play of light and shadow on the deep-set double-hung windows gives added character to the building façade. A corbelled cornice with molding is set between corner piers containing colorful terra cotta inserts. Highly decorated second-story lintels and a third-story stringcourse help give this marvelous building the character and flavor of another time and place.

GEORGE WILLIS PACK

George Pack, a successful lumber entrepreneur from Cleveland, Ohio, came to Asheville in 1884 in search of a healthier climate to alleviate his wife's respiratory problems. For the next twenty years, Pack, desiring to bring civic improvement to Asheville, used his considerable wealth to change the face of the city in diverse ways.

Seeing the need to transform Court Square into a public space for all of Asheville's citizens, Pack successfully negotiated a deed transfer in 1901 that gave the city land on College Street for construction of a new courthouse in exchange for the Court Square property. Pack then deeded the property

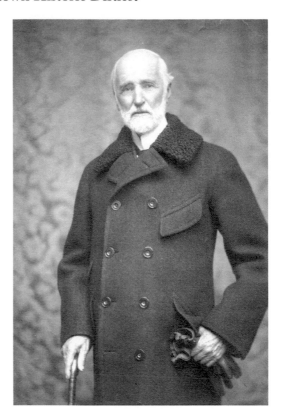

George Willis Pack. *Courtesy of
the North Carolina Collection, Pack
Memorial Public Library, Asheville,
North Carolina.*

to the City of Asheville with the stipulation that "an open park was to be
maintained for the people of Asheville." The existing 1876 courthouse, a two-
story Second Empire structure designed by J.A. Tennent, was demolished,
and a fountain was added. Known thereafter as Pack Square, the area still
carries the name of this great benefactor.

Pack was instrumental in the movement to honor North Carolina's three-
time governor Zebulon Vance by donating a large portion of the cost for
the erection of a monument. Located at the head of Pack Square, the
monument, a tall granite obelisk designed by Richard Sharp Smith, was
dedicated in 1898.

In 1888, Pack provided salaries for teachers at Asheville's first African
American public school, located on Beaumont Street. The following year,
his financial support provided the impetus for the creation of the city's first
kindergarten.

The Asheville library system was given a much-needed boost with Pack's
purchase in 1899 of the old Palmetto building (formerly the First National

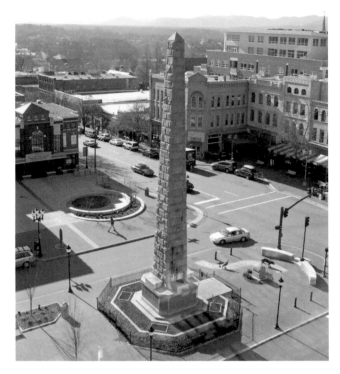

Vance Monument.

Bank), which he donated to the city to be used as a library. The Palmetto building, known as the "castle," was demolished in 1926 and replaced with the Pack Memorial Library.

To honor his good friend Edward J. Aston, Pack donated eleven acres on South French Broad Avenue to be used as a public park, and Aston Park is now one of the Southeast's finest tennis venues. Ill health forced Pack to return to his native New York, where he died in 1906 at the age of seventy-five.

10. GEORGE MEARS HOUSE

The 1885 George Mears House, located at 137 Biltmore Avenue, is an exceptionally fine example of the Queen Anne style of architecture, which was prominent in Asheville from 1870 until 1910. The brick, two-and-a-half-story structure features first-floor semi-polygonal bays that flank the double-leaf paneled main entrance doors. The southernmost bay continues into the

second floor, where it terminates in a semi-polygonal cap over a recessed porch supported by four turned and tapered posts. Fish scale shingles, a prominent motif of the Queen Anne style, abound in the tympanum and within the porch wall.

The veranda wraps around to the south and is supported by tapered porch posts surmounted by decorative brackets supporting the slate-shingled roof overhang. Interspaced between each post is a pendant, or drop, completing the overall effect of solidity and permanence. Gable dormers, with fish-scale tympanums, puncture the slate-shingled roof with a wide banded cornice, supported by brackets, wrapping around the building.

Located just a few blocks from downtown, this Victorian-era house is a constant reminder of the beautiful homes that once flourished in one of the finest residential areas of Asheville.

George Mears, a wealthy entrepreneur, was the owner of the Daylight Store, a dry goods establishment located on Biltmore Avenue that was considered to be one of the finest in North Carolina. The store was so named because of its preponderance of glass, which illuminated the merchandise. After Mears's retirement in 1912, the property was occupied by various businesses until 1943, when fire destroyed the property.

The first example of the Queen Anne style in America was a residence designed by H.H. Richardson in 1874 and built for William Watts Sherman

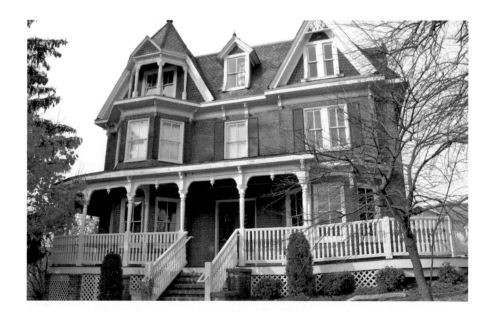

in Newport, Rhode Island. Richardson, the second American to attend the École des Beaux-Arts in Paris, France, became acquainted with this style while traveling in England during his student days. However, it wasn't until Philadelphia's 1876 Centennial Exposition, celebrating the signing of the Declaration of Independence, that a large portion of the public was exposed to this style. As part of an architectural display, the British government erected several buildings, thus giving the approximately eight million fairgoers their first view of this new and visually exciting style. Richard Norman Shaw, an English architect, is given credit for the development of this style.

11. BILTMORE BUILDING

The revitalization of downtown Asheville took a major step in 1979 with the construction of an ultra-modern $5 million corporate headquarters for Akzona, Inc., a major conglomerate in the textile industry. Asheville native and Akzona CEO Claude Ramsey commissioned the architectural firm of I.M. Pei and Partners of New York to specially design a unique seven-story building to replace several 1880s commercial structures at North Pack Square. The new building represented a visible commitment to the regeneration of downtown versus the expanding suburbs. One of the most striking external

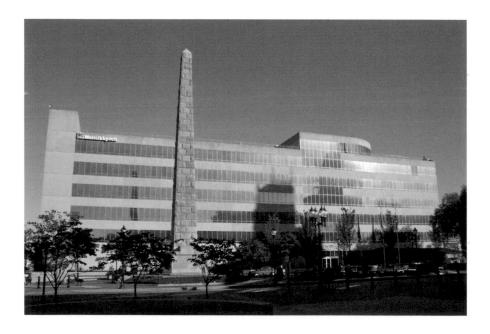

features of the structure is its floor-to-ceiling coated windows that provide a beautifully reflected image of the surrounding Asheville architecture.

An economic downturn in 1982 forced Akzona to downsize, leaving the building available for purchase. In 1986, the Biltmore Company was ready to construct its corporate headquarters on the estate property near its main entrance. Instead, William A.V. Cecil stepped in to purchase the 144,000-square-foot property and renamed it the Biltmore Building as a further pledge to the revival of the struggling Asheville downtown. Mr. Cecil was a pioneer not only of preservation at Biltmore Estate but also in the ongoing redevelopment of downtown, as improvements there have continued over the past twenty-plus years.

I.M. (Ieoh Ming) Pei was born in China in 1917. He came to America in the 1930s and received his bachelor's degree in architecture from the Massachusetts Institute of Technology in 1940 and a master's degree from the Harvard Graduate School of Design in 1946. Pei became a naturalized citizen of the United States in 1954 and formed his own firm the following year. Since then, his firm has created such outstanding works as the Louvre Pyramid in Paris (1989), the Rock and Roll Hall of Fame in Cleveland (1995), the John Hancock Tower in Boston (1976), the Mile High Center in Denver (1956) and the East Building addition to the National Gallery of Art in Washington, D.C. (1978).

12. ASHEVILLE ART MUSEUM

Renowned New York architect Edward L. Tilton, utilizing the Second Renaissance Revival style that was prominent in America from 1890 to 1930, designed the Pack Memorial Library (1926), now known as the Asheville Art Museum. This distinctive style incorporated rectangular or square shapes on a relatively flat façade organized into distinct horizontal divisions separated by belts or stringcourses. Each floor or division was fashioned to reflect a unique design element.

Tilton's design incorporates Georgia marble veneering and is divided into three distinct levels. A round-arched, multistory entrance bay features a console keystone. The first floor has double-leaf entrance doors with transom, all under a heavy shelf architrave with flanking console brackets. Bronze lanterns and six rectangular windows flank the entrance doors above a limestone water table.

A stringcourse signals the beginning of the second level. The upper portion of the entrance bay contains a large, multi-paned arched window

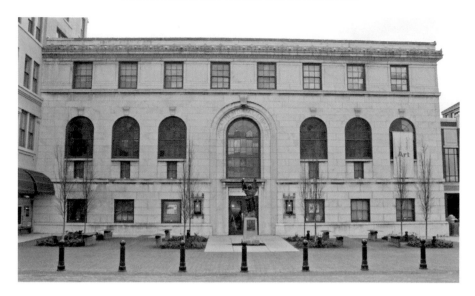

flanked by six Roman arched windows, each containing a console keystone above narrow, rectangular inset windows.

The third level, separated by a belt course, contains six-over-six double-hung rectangular windows spaced with intervening square blocks. Classical details abound at the cornice level with the inclusion of dentil moldings, egg and dart moldings and a row of stylized anthemion leaves interspersed between undulating plant motifs and grotesques.

By the early 1970s, the library had become overcrowded, and J. Bertram King was hired to design a new library to be located on Haywood Street. The new library building was completed in 1978, and the old Pack Memorial Library was incorporated into Pack Place as the Asheville Art Museum.

Edward L. Tilton (1861–1933) was an American architect who specialized in designs for libraries and educational institutions. He served his apprenticeship at the prominent New York architectural firm of McKim, Mead and White. He attended the prestigious École des Beaux-Arts in Paris from 1887 to 1890. With William Boring as his partner, they were successful in winning the 1897 competition for the U.S. Immigration Station on Ellis Island. Tilton is credited with the design of over one hundred libraries, with many built as Carnegie libraries. He was an advocate of the Open Plan— shelves provided on the main floor for the more popular books. He was a leader in library design until his death in 1933.

13. LEGAL BUILDING

In 1909, Richard Sharp Smith, showing his creative versatility, designed a five-story office building in the Italian Renaissance Palazzo style. Named the Legal Building and located at 10–14 South Pack Square, it is one of the first uses of reinforced concrete in Western North Carolina. The stucco-faced building features a second-story entablature supported by decorative engaged columns. The building is crowned by a massive cornice of sheet metal containing modillion blocks and supported by paired brackets. The five-bay symmetry of the façade is broken by the clipped corner facing the Vance Monument. Windows are double-hung with one-over-one lights.

Some notoriety was attached to the Legal Building when, on February 25, 1931, Asheville mayor Gallatin Roberts committed suicide on the fourth floor. Roberts, along with several public and Buncombe County bank officials, was indicted for banking irregularities in connection with the Central Bank & Trust Company of Asheville.

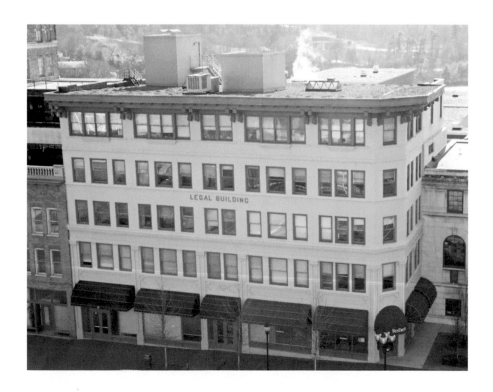

14. WESTALL BUILDING

This eight-story steel-frame commercial building on South Pack Square was built in 1924 by William Harrison Westall in combination with the Jackson Building. Designed by Asheville architect Ronald Greene to share one elevator, the two buildings effectively combined to become one large office complex under the management of L.B. Jackson.

Initially conceived as a Gothic twin to the Jackson Building, the final design of the Westall Building incorporates the lavishly decorated English Norman and Spanish Romanesque styles. The two-story main entrance block of orange ashlar is inset within a border of striped cable molding. A single-leaf multi-paneled wooden front door with multiple lights is enclosed within a flat arch. The entrance is surmounted by an ornate arcade of engaged Norman columns divided by eight-light casement windows. Cushion capitals, so named because they resemble a cushion pressed down by a heavy weight, rise above each column. Supporting the

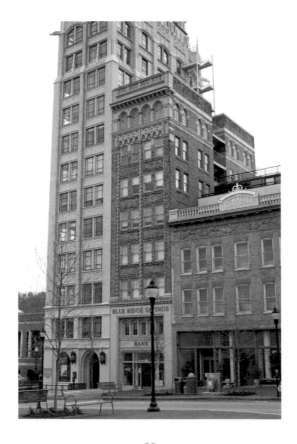

arcade is a frieze of terra cotta moldings, including egg and dart, pateras flanked by rectangular insets and dentil-like strips.

The third through seventh floors are brick-faced and framed with cable molding. Flemish bond brickwork patterns are applied between the windows, with running bond elsewhere. Windows are double-hung, with six-over-one sashes.

Rising above the seventh floor is a richly arcaded frieze of Norman pointed double arches decorated with polychrome terra cotta moldings. A bracketed, balustraded parapet in sparkling terra cotta polychrome surmounts the eighth-floor Roman arched arcade.

William Harrison "W.H." Westall was a wealthy businessman and influential lumber magnate. He was a younger brother of Julia Wolfe, the mother of author Thomas Wolfe of *Look Homeward Angel* fame.

15. JACKSON BUILDING

The Jackson Building, located on South Pack Square and completed in 1924, was the first skyscraper built in Western North Carolina. The building was designed by Asheville architect Ronald Greene in neo-Gothic style for the twenty-eight-year-old real estate developer Lynwood Baldwin "L.B." Jackson. The steel-framed, cream-colored, brick and terra cotta office building rises thirteen stories from a limestone base, terminating in a Mission-style penthouse and equipment tower. Heart-shaped tracery over fanciful grotesques (often misnamed gargoyles) surrounds the penthouse level.

The building's brick construction is in the stretcher bond pattern. Window spandrels are recessed panels of stack bond (headers laid in a column), with nine-pane casement windows used throughout. The deep-set arched entrance, flanked by cast-iron lanterns, features foliated spandrels over an archivolt of evenly spaced foliated inserts.

Built on a small corner lot measuring only twenty-five by sixty-two feet, the pencil-thin building, only two bays wide, was built in conjunction with the Westall Building, with which it shares an elevator. The Jackson Building once held the monument shop of W.O. Wolfe, the father of author Thomas Wolfe. Wolfe occupied the site until 1918, when poor health forced him to retire. The property, originally purchased for $1,000, sold for $25,000 in 1920. Several businesses occupied the site until 1923, when Jackson purchased the property.

The Gothic style, used traditionally for religious structures, was adapted for commercial buildings in New York's 1913 Woolworth Building and the

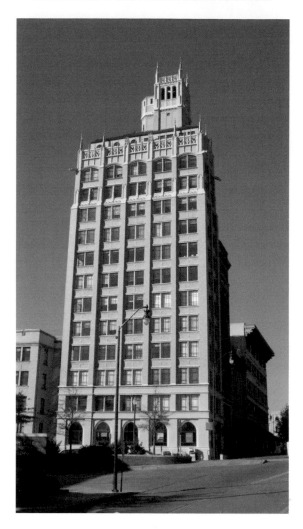

Chicago Tribune Tower in 1923. Adding a touch of Old World classical detailing to twentieth-century structures enhanced the expression of verticality and demonstrated that old and new styles could be melded to create an acceptable composite style.

To promote the city of Asheville and develop his real estate business, Jackson saw the merit of constructing a unique building whose style would proclaim that he and Asheville had arrived. Although fully rented prior to completion, the building's high cost of construction offset the revenue it generated, which resulted in Jackson only breaking even on his investment. Nevertheless, the building remains a testament to the energetic and driving

energies of Jackson, whom many consider a real estate genius. Seeking to place his name throughout Asheville, Jackson was famous for the large steel-framed, open-air rooftop signs that proclaimed, "See LB."

Born in Georgia, Jackson came to Asheville in 1915 when his father purchased a Chero-Cola bottling plant. Using profits from his patent on a bottling inspection machine and the manufacture and distribution of punch boards, Jackson began building homes for resale, gradually expanding into large-scale residential and commercial development. LB was a mannerly southern gentleman—he always wore a coat and tie—and had a special ability to connect with people at any level of society and to talk on any subject. Jackson's work resulted in the development of many residential areas, including Beverley Hills, Royal Pines and Malvern Hills, along with extensive construction on Kimberly Avenue. His commercial accomplishments included involvement in the Asheville-Biltmore Hotel (Altamont Apartments), the Flatiron Building, the Grove Arcade (with W.P. Taylor) and the Woodfin Apartments (now an office building). Jackson died in Fort Lauderdale, Florida, in 1974 at the age of seventy-seven.

The years have been kind to Mr. Jackson's building. Eighty-plus years after its construction, there is still a fascination with the look and feel of this unique piece of historic architecture. The "gargoyle" building will forever remain the queen of Asheville's historic downtown district.

16. MUNICIPAL BUILDING

The Municipal Building of Asheville, completed in 1926, is a squat, rectilinear, two-story structure located on South Pack Square. Through the combined efforts of architect Ronald Greene and brick mason James Vester Miller, the red brick building comes alive with rustication on two levels, limestone trim and Neoclassical detailing. Three groups of paired Tuscan columns frame the second-floor balcony over the fire department. A belt course and corbeled cornice circumscribe the exterior.

Greene and Miller used their artistic imaginations to produce a fanciful representation of a Roman portico on the façade facing Market Street. Centered within a pedimented pavilion, a recessed portal features engaged Tuscan columns and flanking coupled windows. The Roman arch entrance below displays an intricate overdoor composed of the numbers "1925" in bas-relief flanked by cornucopias that indicated utilization of the basement area as one of the finest food markets in the Southeast.

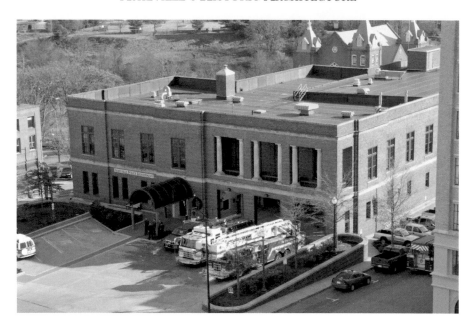

The building's original occupants included the police, fire and health departments, the city jail and courts for police and juvenile offenders. Only the fire and police departments remain today.

17. YOUNG MEN'S INSTITUTE (YMI) BUILDING

The Young Men's Institute, or YMI, Building, located at the corner of South Market and Eagle Streets, was completed in 1893 under the direction of Richard Sharp Smith, the supervising architect for George Vanderbilt's 250-room French Renaissance mansion being constructed near Asheville. Following the recommendation of Professor Edward L. Stephens, principal of Asheville's first African American public school started in 1888, Vanderbilt provided the financial support for the erection of a building to benefit Asheville's African American community. His gifts provided housing for some of the hundreds of African American men employed in the construction of his estate, and the building served the area as a recreational and community center.

Created in the English vernacular style reminiscent of Richard Morris Hunt's designs for estate-related buildings in Biltmore Village, the two-and-a-half-story structure incorporates pebbledash wall finishes, brick window embellishments and first-floor retail shop fronts. Heavy wooden

brackets support the red-shingled hip roof and first-floor pent roofs. The main entrance, located on Market Street, has a wide brick archivolt of red brick decorated with quoins. Major building corners and window surrounds contain brick quoining, providing a picturesque contrast with the light-colored pebbledash. Windows are generally double-hung with eight-over-one lights.

In 1905, Vanderbilt, seeking to turn control of the YMI over to the African American community, agreed to a sale price of $10,000, provided the purchase price could be met within a six-month period; otherwise the building would be placed on the open market with a purchase price of $15,000. In early 1906, the Young Men's Institute was formally incorporated, and a fund drive was begun. About $2,500 of the $10,000 was successfully raised, with the difference being put into a mortgage, which was paid off in 1913.

From the beginning of the Great Depression in 1929 until the early 1940s, membership and usage gradually diminished, and with time and lack of care adding to the building's woes, its closing was inevitable. In 1945, however, after reorganization and renovation, the building was again opened for business. It was sold the following year to the Market Street Branch of the YMCA and continued to be of service to the African American community until 1976, when extensive repairs and upkeep necessitated the closing of the branch.

The building sat idle until 1980, when the YMI Cultural Center, newly incorporated to provide support for the African American community, purchased the property. After extensive renovations, the building officially opened in 1988. The Cultural Center continues to serve in the areas of history, cultural arts, employment training, minority enterprise and community redevelopment.

The building was placed on the National Register of Historic Places in 1977.

18. Mount Zion Missionary Baptist Church

Built in 1919 as the home of one of Asheville's largest African American congregations, Mount Zion Missionary Baptist Church is located on Eagle Street. It is a striking red brick Late Victorian Gothic building, featuring three imposing towers arrayed around a metal-shingled roof. Sheet-metal finials adorn the top of each tower. The foundation is uncoursed quarry-faced granite. James Vester Miller, Asheville's master brick mason, included three types of brickwork patterns in this building: American (common) bond, stretcher (running) bond and a combination of Flemish and American bond. A combination of hood-molded lancet windows and

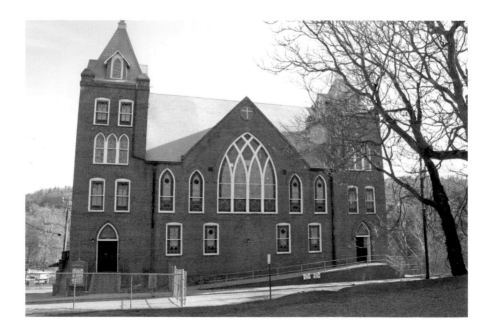

segmentally arched windows, both containing fine examples of art glass, are employed throughout.

On Sunday morning, the sanctuary is filled with music from an A.B. Felgemaker organ, the only one of its type in North Carolina. Originally installed in Asheville's First Baptist Church, the organ became the property of Mount Zion in the 1930s. It was fully restored in 1987.

The Reverend Robert Parker Rumley originally organized Mount Zion Church in 1880. His influence was described in the December 15, 1983 issue of the *Asheville Citizen-Times*:

> *Rumley preached many sermons, but he was best known for his message on "De Dry Bones in De Valley," which on occasion he would deliver on Pack square.*
>
> *It is said that people came from all over to hear him and in later years, his sermons had a profound influence on Thomas Wolfe when he wrote the book* Child by Tiger.

Following Reverend Rumley's resignation in 1897, the Reverend Jacob Robert Nelson guided the church in acquiring property for the purpose of building two smaller churches prior to completion of the present building. When the new church was finished, Miller donated $1,000 in honor of Reverend Nelson and accepted no compensation for his services.

19. City Building of Asheville

The eight-story City Building of Asheville, completed in 1928, was the vision of architect Douglas Ellington. Taking the principles of Art Deco styling and blending it with classical motifs, Ellington created a building that has stood the test of time and is as breathtaking in concept and appearance today as it was when completed. His design concept was of a building of "fortress-like strength" that would rise from a base of pink Georgia marble, continue through three brick setbacks and end in a majestic pink-and-green-tiled terra cotta octagonal ziggurat under a carillon tower.

The main entrance setback features a three-arch arcade over which the building's name is engraved in Roman lettering. A frieze of vertical chamfered marble blocks above a block modillion cornice encircles the first floor of the building. Flanking the entrance are two impressive octagonal lights elevated on monumental square bases; each light features feather-

motif leading with polychrome glass inserts. Three octagonal lamps similar in design to the entrance lights hang by sturdy chains from the groin-vaulted ceiling of the loggia. The ceiling and wall surfaces are decorated with multihued mosaic tiles that terminate in a five-foot-high pink Georgia marble wainscot surrounding the loggia. The floor is laid in thirty-inch square slabs of dappled pink and gray marble. Two City of Asheville seals are displayed in low relief at each end of the loggia above heavy brass double-leaf doors with twelve-inch-wide marble surrounds. The same coloration and material of the wainscot is found in the archivolts surrounding the three majestic Roman arches, similar in design to a Diocletian window. A standard-size, brass, double-leaf, glass-paneled door, centered within each arch, initially provided entrance to the main building's elevator lobby.

Ellington's ability to blend the old with the new is stylistically shown on the second level, where three tall marble-framed casement windows are surrounded by a classical mutuled pediment, engaged columns and a stylized feather motif framed by vines and rosettes.

The concept of verticality is achieved through the dramatic use of three monumental sculptures, detailed with additional stylized feather motifs, rising through the angled lintels of the seventh-floor casement windows and terminating

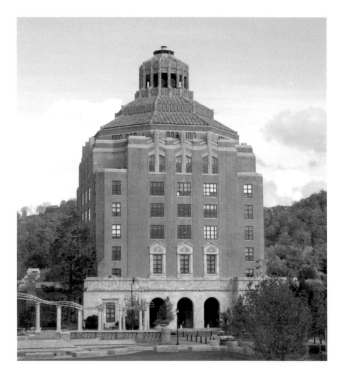

above the cornice line. The vertical feather is indicative of Ellington's interest in Indian motifs, and his repeated use of this decoration is found in elements of the First Baptist Church and the Merrimon Avenue Fire Station.

Art Deco takes its name from the Exposition Internationale des Arts Decoratifs et Industriels Modernes, held in Paris in 1925. Shunning all past architectural styles, Art Deco sought to create a new method of decoration that could be applied not only to architecture, fashion and graphic arts but also to industrial design ranging from furniture to automobiles. Art Deco decoration consists of low-relief geometrical shapes in the form of chevrons, zigzags, building setbacks and stylized floral motifs. In addition to the City Building, Ellington utilized the octagon as a design feature on the facade of the S&W Cafeteria, the First Baptist Church dome and the entrance to the Lewis Memorial Park in the Beaverdam area.

Ellington's original design concept called for the Buncombe County Courthouse to be of a matching architectural style; however, last-minute considerations for a more conventional and conservative design led the county commissioners to hire the firm of Milburn and Heister of Washington, D.C., to design the courthouse. Plaster models of the current City Building and Ellington's projected design for the County Courthouse are on display in the elevator lobby of the City Building.

In 1932, a set of ten-tube chimes was installed as a memorial to the Buncombe County soldiers who died in World War I. The Ladies' Auxiliary of the American Legion initiated a local drive to obtain the necessary funding for the project.

From 1943 to 1946, the building was rented by the U.S. Army Air Corps' Flight Control Command or Weather Wing. As the administrative headquarters for the army's world weather service, the Weather Wing's function was to supply observers and forecasters for regions throughout the world. A separate unit called the Air Corps' Communications Wing shared space within the building.

The City Building of Asheville was placed on the National Register of Historic Places in 1976.

20. BUNCOMBE COUNTY COURTHOUSE

The eighth Buncombe County Courthouse, designed in the Neoclassical style by the firm of Milburn and Heister, is a seventeen-story, steel frame, brick and ashlar structure. At the time of completion in 1928, it was the largest courthouse in North Carolina.

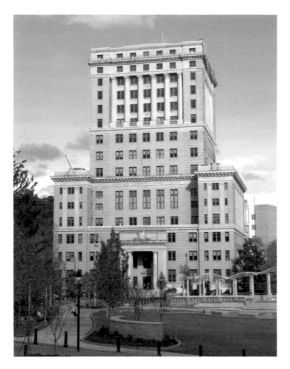

The overall appearance is that of a tall, rectangular, three-tiered building. Rising above the two-story basement, the first three levels of rusticated ashlar terminate in a belt course, with the fourth through sixth floors forming the first setback. Ionic pilasters separate the windows of the flanking wings, while a full entablature of modillion blocks and dentil moldings rises above.

Above the sixth floor is a nine-story superstructure with embedded Corinthian columns and a two-story attic. The use of the upper six stories as a county jail was a trademark of Milburn and Heister's courthouse designs.

The original main entrance pavilion is three stories high, framed by Doric columns of granite. A full entablature and centered cartouche completes the classical effect. For security reasons, the main entrance is now located on College Street.

When Douglas Ellington designed the City Building of Asheville, it was to be part of a matching pair with the courthouse. In 1926, the city and county officials agreed to erect twin buildings joined by an arcade, based on Ellington's design. However, in 1927, the county commissioners, unhappy with the avant-garde Art Deco style of the City Building and desiring a more conservative approach, awarded the contract to Milburn and Heister. The firm was unrivaled in the Southeast for courthouse design, having designed twelve in North Carolina alone.

Due to declining health, Frank Milburn, the principal behind the firm's success, had retired to Asheville, where he died in 1926 at the age of fifty-six, shortly before his Buncombe County Courthouse design was selected.

The building was placed on the National Register of Historic Places in 1979.

21. HOPKINS CHAPEL AFRICAN METHODIST EPISCOPAL ZION CHURCH

The architectural firm of Smith and Carrier designed this Gothic Revival church in 1910. Located off College Street on College Place, it was built for the African Methodist Episcopal Zion Church, an African American group that had broken away from Central Methodist Church in 1868. Built of brick with a quarry-faced masonry foundation, the building's main façade has three symmetrical doors placed in three distinctly different sections. Dominating the center is a parapet gable section with a large three-part lancet stained-glass window. A tall square tower on one side is punctured by three lancet windows, while a shorter tower on the other side, complete with single-lancet windows, completes the asymmetrical look. The large three-part stained-glass window repeats on the east and west façades, balanced by four double-lancet windows.

Typical of Gothic churches is the use of buttresses to contain the outward thrust of the wall. Brick mason James Vester Miller placed buttresses on three sides of the church in two different designs. The buttresses across the front and around both towers have an intricate angular design, while those along the sides have a more traditional look. The overall brickwork pattern is of the American or common bond pattern, where every seventh course

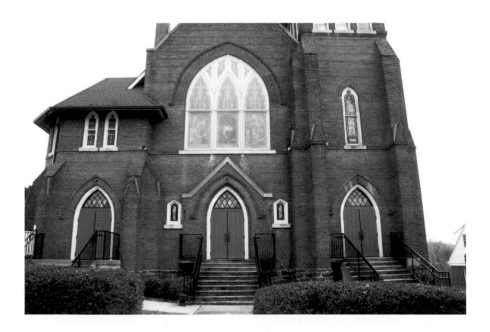

consists of headers and the other courses are stretchers. The brickwork over all the doors and windows is of particular note. This is a building to walk slowly around and absorb the beautiful way that Miller has made brick an art form.

JAMES VESTER MILLER

James Vester Miller came to Asheville as a child in the 1860s and remained to create many of the city's most beautiful and enduring brick structures. Miller was born in 1860 in Rutherfordton, North Carolina, to Louisa Miller, a thirty-eight-year-old slave mother, and a white father. Louisa arrived in Asheville by wagon with her three children and took up residence in the Baptist Hill neighborhood, eventually gaining employment as a cook for Julia Wolfe at the Old Kentucky Home boardinghouse. James Miller would go on to leave a lasting legacy of his artistic genius in the many churches, public buildings and residences that still stand today. As an artist uses a palette in painting, Miller was able to use brick as a special art form, creating intricate designs that stamp his work as that of a master builder. As a child, Miller, not being overly fond of school, often spent his time instead at local building sites, working odd jobs and learning the bricklaying trade. He eventually formed his own company, Miller and Sons, and was so well respected for his skill, honesty and devotion to his calling that he was able to work in both the African American and white communities, completing numerous projects for the Coxe and Millard families.

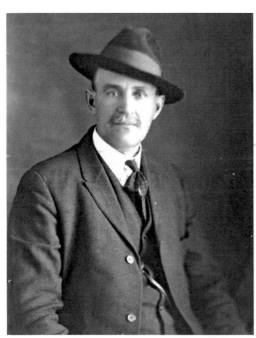

James Vester Miller. *Courtesy of the North Carolina Collection, Pack Memorial Public Library, Asheville, North Carolina.*

In 1881, he married Violet Agnes Jackson. Their union produced five boys and one girl. All of the boys learned the

bricklaying trade from their father and became successful businessmen of their own, with the exception of Miller's third son, Lee Otus, who found his calling in the medical profession. After graduating from Boston University with a medical degree, Lee Otus returned to Asheville in 1918 with his wife, Daisy, to practice medicine as one of three African American doctors in the area.

In the late 1890s, James Miller constructed a large brick family home in the Emma section of Buncombe County and acquired numerous landholdings and other residential property along Brickyard Road. In the mid-1930s, he partnered with Lee Otus to establish a cemetery for African Americans. Named Violet Hill for his wife and located on Hazel Mill Road, it still serves the African American community. James, Violet and many other family members are buried in this cemetery. According to Miller's daughter, Annie Mae Bolden, deteriorating health forced Miller to be bedridden for the last five years of his life. He died at his home in Emma in 1940 near his eightieth birthday.

The following list of buildings still standing are evidence of Miller's genius at making brick an art form that is unrivaled in Western North Carolina: the Gothic-style **St. Matthias' Episcopal Church** (1894–96), where Miller and his family were members; the **Medical Building** (circa 1900) on Government Street (now College Street), which was designed in the Neo-Georgian style by Richard Sharp Smith; **Hopkins Chapel AME Zion Church** (1910), also designed by Smith; the Gothic Revival **Mount Zion Missionary Baptist Church** (1919); the **Municipal Building** (1924), which was the home of a thriving public market and now houses Asheville's fire and police departments; the Gothic Revival **St. James AME Church** (1924–31), located at the corner of Martin Luther King Jr. Drive and Hildebrand Street; and **Varick Chapel** (circa 1920s) at 308 South French Broad Avenue.

22. First Baptist Church

One of the more interesting combinations of Old World architecture and modern styles in Asheville is the First Baptist Church, which remains a unique example of the inventive genius of its designer, Douglas Ellington. The church, built in 1927 and located at 5 Oak Street, is a combination of Renaissance, Art Deco and Beaux-Arts designs.

The double-shell dome, built on an octagonal base, follows the example set by Renaissance architect Filippo Brunelleschi with his Cathedral of Santa Maria del Fiore in Florence, Italy. Ellington combined Brunelleschi's Renaissance dome with the Beaux-Arts ideals he had learned as a student

at the École des Beaux-Arts in Paris and added Art Deco details and a Renaissance dome to create a lasting contribution to the architectural heritage of Asheville.

The main façade is composed of a monumental two-story portico supported by six chamfered brick columns. Surmounting each column is a stylized capital composed of vertical brick elements set in a double-row sawtooth pattern under a molded terra cotta cap. The nontraditional entablature, illustrating the creative design versatility of Ellington, features an architrave and cornice of alternating terra cotta inserts of nail heads and palm leaves. Inset within the frieze is a rectangular marble slab with the church's name engraved in Roman lettering and flanked by square frames of brick headers, within which octagonal brick headers circumscribe an octagonal marble insert; each axis of the insert is appended to a smaller half octagon. An attenuated pediment crowns the entablature. The frieze, containing square marble inserts, alternates with the octagonal motif found in the entablature and continues around the periphery of the auditorium.

The coffered porch ceiling supports three octagonal lanterns hanging from sturdy metal chains, while below, the marble entrance floor is inset with a pattern of five interlocking octagonal shapes. In keeping with the monumental scale of the portico, Ellington created a triple-door grand

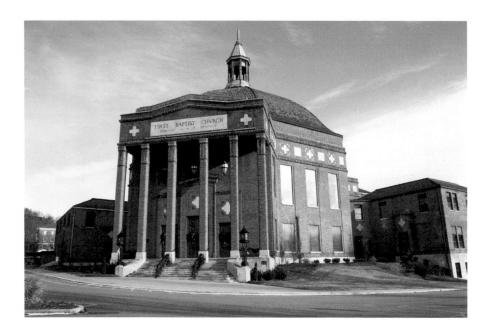

entrance; the center door is the tallest, at twelve feet, and features a double-leaf, split-level design with a series of raised panels decorated with an eight-pointed star configuration. The shorter flanking doors are similar in design and complement the overall sense of proportion and scale. Over-door designs reflect the octagonal motif found in the entablature.

The main building material resembles handmade brick used in the early eighteenth century and gives the structure a variegated appearance that glows and shimmers from the play of light and shadow throughout the day. Ellington's background as an accomplished watercolorist is exemplified in his selection of terra cotta roofing tiles for the ninety-foot steel-ribbed dome. From the open-sided verdigris-covered octagonal copper cupola, colors flow from green down through a brilliant orange and terminate in a red reminiscent of the building's façade.

The octagonal theme found throughout the building is strikingly evident in the ten-foot free-standing steel lanterns that flank the marble entrance stairs. From its base through the eight spiral legs to the eight-sided octagonal lights and the triple cap, the lanterns' entire design personifies Ellington's penchant for the octagon. He utilized this same geometric shape as a design feature on the façade of the S&W Cafeteria, the City Building of Asheville and the entrance to Lewis Memorial Park in the Beaverdam area.

Lewis Memorial Park entrance office.

From the original building configuration, described in the 1930 *Architectural Record* as "being a group of five buildings that pyramid into a single structure," the church expanded its facilities to include a three-story Children's Building in 1970, followed by the Family Ministries Center in 1980, which included a gymnasium, recreation area, dining facility and classrooms. In 1987, the center was renamed the Sherman Family Ministries Center to honor Dr. Cecil Sherman, church pastor from 1964 to 1984. In 2007–8, a secondary entrance was constructed facing 1 Oak Plaza to the south, providing access to administrative offices, recreational areas, classrooms and dining facilities. This entrance is approached through an attached open-sided octagonal covering whose pyramidal roof of translucent panels is supported by eight sturdy octagonal brick columns. The concrete walkway features concentric octagons.

The church was placed on the National Register of Historic Places in 1976.

Douglas Ellington

The golden years of architectural design for Asheville began with the arrival of Douglas Ellington in 1926 to create the First Baptist Church of Asheville. During the six short years of his residence in Asheville, Ellington transformed a staid, conservative town into an exuberant display of brilliant colors and geometric shapes. Using Beaux-Arts principles, with Art Deco detailing, Ellington designed public buildings that stand today as tributes to his visionary approach. While many residential projects were completed under his guidance, it is the following public buildings that stand in vibrant testimony to his brilliance: the City Building of Asheville, the S&W Cafeteria, Asheville High School, Biltmore Hospital, the Merrimon Avenue Fire Station and the First Baptist Church.

Ellington and his two brothers—Kenneth and Eric—were born to Jesse Ellington and his second wife, Sallie, in Clayton, North Carolina. Kenneth completed law school and became Douglas's business partner. Eric, a graduate of the Naval Academy, died in 1913 as result of a flight training accident in Houston, Texas. Ellington Field was named in his honor.

Douglas Ellington attended Randolph-Macon College in Virginia, the Drexel Institute in Philadelphia and the University of Pennsylvania. In 1911, he won the Paris Prize, awarded by the Society of Beaux Arts Architects in New York. The winnings from the prize enabled him to attend the École des

Beaux-Arts in Paris, the leading architectural design school in the world. He became the first American to receive the Prix de Rougevin—awarded for decorative competition.

During the First World War, he returned to the United States and enlisted in the United States Navy's newly created camouflage program. Talented artists and architects were enlisted to design alternative methods of painting ships—called dazzle painting—to confuse the German U-boats that were a menace to Allied shipping. After his discharge, Ellington began teaching at the Drexel Institute, Columbia University in New York and the Carnegie Institute of Technology in Pittsburgh.

While teaching at Carnegie, he began a private practice in Pittsburgh, with his brother Kenneth as office manager. In 1926, upon receiving his commission to build the First Baptist Church of Asheville, he moved to Asheville, along with Kenneth and Kenneth's family.

Douglas Ellington.
Courtesy of Sallie Ellington Middleton.

In 1926, Ellington purchased a log cabin on several acres of wooded property at the end of Chunn's Cove. Over the next several years, two sections were added to the cabin: an uncoursed stone central block and a multicolored brick section that houses a second-floor master bedroom over a kitchen-dining area. The added sections were fanciful expressions of Ellington's artistic bent and were composed of salvaged material along with leftover items from several of his construction projects. The overall complex defies architectural description, reflecting the fertile artistic imagination of Asheville's Art Deco master. Ellington's niece, renowned wildlife artist Sallie Middleton, resided in the house until her untimely death in 2009. In 1989, the house was designated a local historic landmark by the Asheville-Buncombe Historic Resources Commission. Ellington sold the Chunn's Cove house in 1932 to his sister-in-law Margaret and moved to Washington, D.C., to be involved, along with fellow architect Reginald S. Wadsworth, in designing structures for the federal government's first three planned communities. The first, called Greenbelt, is located thirteen miles northeast of Washington in Maryland. The purposes of the project were to provide low-cost housing, to help alleviate the acute housing shortage and to create employment for the nation's labor force. Hand labor, in lieu of mechanical means, was extensively used to maximize the number of available jobs—more than thirteen thousand were created. Over 1,700 modern residential units were constructed, with another 1,000 being added in 1941 for "defense" workers.

In 1937, upon completion of Greenbelt, Ellington moved to Charleston, South Carolina, to rework the historic Dock Street Theater. The theater, originally built in 1736, is considered to be the first building in the United States designed strictly for theatrical use. Following the destruction of the theater by fire on two separate occasions, the site was used for construction of Charleston's famous Planter's Hotel in 1806. After years of decline, the hotel was rescued by a group of concerned Charleston citizens, who, in conjunction with the Federal Emergency Relief Administration and the Works Progress Administration (WPA)—both creations of Franklin Delano Roosevelt's New Deal—initiated work that would incorporate a new Dock Street Theater into the existing remnants of the old Planter's Hotel. The newly restored theater opened in December 1937.

Although he remained in Charleston to practice architecture, Ellington was a frequent visitor to the Asheville area, completing several public and private projects during his visits. Ellington died in 1960 at the age of seventy-two. He is buried at his former Chunn's Cove residence, along with his brother Kenneth, his sister-in-law Margaret, his nephew Eric and his niece Martha.

23. Interchange Building

The Interchange Building was originally constructed in 1929 as a nurses' home for Mission Hospital. In appreciation for the wonderful care that he had received as a patient, and the overall excellence of the hospital, Edward D. Latta, a Charlotte millionaire who had moved to Asheville, left funds for the building in his will. In his honor, the building was named the E.D. Latta Nurses Home.

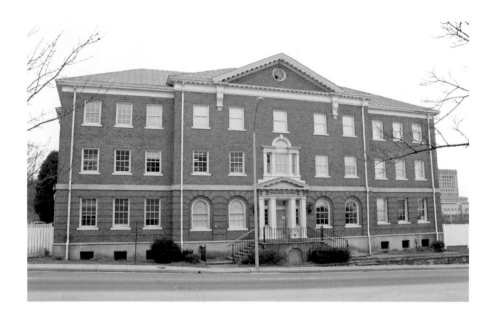

William and Anthony Lord designed the three-story English bond brick building, located at 159 Woodfin Street, in the Neo-Georgian style, which remains the finest example of this style in Asheville.

The central pavilion, five bays wide, is topped by a mutuled pediment. The area within the pediment, called the tympanum, houses a round window. Two scroll brackets complete the symmetrical upper-level design.

The main entrance features a mutuled pedimented portico with sidelights and a transom. A Palladian window and keystone arch with four Tuscan columns complete this beautifully balanced classical composition. Other notable features are the rounded stone water table, the rustication and Roman arched windows on the first floor, a belt course above the first floor and standing-seam metal hip roofs. The original interior provided for nurses'

bedrooms, suites for nursing supervisors, sitting and living rooms, recreation rooms, kitchen facilities, a chemistry lab and demonstration and lecture rooms.

The Parkway Office Building, located directly across the street, was originally designed as Mission Hospital. Built in 1913, with additions in 1923 and 1938, the hospital continued service until 1954, when the construction of new facilities on Biltmore Avenue allowed the building to be sold.

The Interchange Building, now owned by Buncombe County, is used for administrative offices and a day-care facility.

The Interchange Building was placed on the National Register of Historic Places in 1979.

ANTHONY "TONY" LORD

Renowned Asheville architect Anthony "Tony" Lord can aptly be described as a Renaissance man—well versed and knowledgeable in the fields of art and science. Born in 1900, Lord was influenced by his father, William Henry Lord, a local architect; his mother, Helen, who imbued him with a love of literature and history; and his aunt, who introduced him to the world of charcoal drawing and watercolor painting.

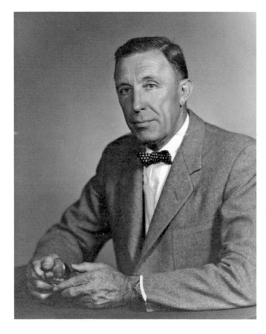

Anthony "Tony" Lord. *Courtesy of the North Carolina Collection, Pack Memorial Public Library, Asheville, North Carolina.*

Lord graduated from Asheville High School in 1918 and received his bachelor of science degree in engineering from the Georgia Institute of Technology (Georgia Tech) in 1922. Encouraged by his parents to expand his educational opportunities, he traveled to New York City for extended classes at Columbia University and the Art Students League, where he developed his skills in sketching and watercolor painting. The final step in his educational journey was accomplished at Yale University, where Tony completed a two-year course of

study in 1927, earning the degree of bachelor of fine arts in architecture. Following graduation, Lord and a group of college friends traveled extensively in France, England, Italy and North Africa. He returned to the United States in 1928 with an extensive collection of photographs in addition to a large collection of his original sketches and watercolor paintings. Upon his return to Asheville, Lord joined his father in the architectural firm of Lord and Lord.

The onset of the Great Depression in 1929 effectively dried up architectural commissions, prompting Lord to create a small blacksmithing business known as Flint Architectural Forgings adjacent to his father's house on Flint Street in Asheville. Over time, the business expanded to a staff of five, with work being shipped to locations at Yale University in New Haven, Connecticut, the Washington Cathedral in Washington, D.C., and several residences in Asheville's Biltmore Forest.

Lord's first large building commission, an ultra-modern asymmetrical design in the International style, was for the *Asheville Citizen-Times* newspaper in 1938. He provided interior light by utilizing large blocks of translucent

Asheville Citizen-Times newspaper building. *Courtesy of the North Carolina Collection, Pack Memorial Public Library, Asheville, North Carolina.*

glass divided by belt courses of stucco applied to ashlar blocks, giving the building a decidedly horizontal look. An off-center stair tower uses vertical glass blocks for illumination, breaking up the uniformity of the front façade, giving it an asymmetrical appearance.

World War II again halted construction of small residential and commercial projects due to the diverting of essential materials to military construction. In order to obtain large government contracts, Lord, in 1941, teamed with Charles Waddell, William Dodge, Stewart Rogers, Erle Stilwell and Henry Gaines to form the architectural firm of Six Associates.

Lord's enthusiasm for nature led him to donate two trees for planting in Pritchard Park in 1945 and to wage a concerted effort to convince Asheville city officials to beautify the city by planting and maintaining trees and other vegetation, thus ensuring that existing plantings would be retained in the face of new construction.

Lord's love of books and literature led to his 1945 appointment to the Asheville City Library System Board, for which he served as chairman from 1959 to 1979. During his tenure, the library expanded to serve the African American community with a branch located in the Young Men's Institute (YMI) Building and four new branch libraries constructed in Asheville as well as Skyland/South Buncombe, Black Mountain and Swannanoa. When crowding became an issue in the early 1970s, the library board hired architect J. Bertram King to design a new library on Haywood Street. That building was completed in 1978, with the old Pack Memorial Library building being incorporated into Pack Place as the Asheville Art Museum.

Adopting an idea from his college days, when schools regularly published and shared a calendar of artistic events, Lord was instrumental in founding the *Arts Journal*, which incorporated a calendar of up-to-date information on current artistic programs in the Southeast, along with timely articles. The *Arts Journal* began publishing in 1976 and continued until 1992.

Lord's major architectural accomplishments include the University of North Carolina at Asheville Library (1963), with assistance from William E. McGeahee; the Warren Wilson College Library (1964) and Schaffer Dormitory (1967); the Black Mountain Library (1968); the Montreat Community Center (1963); the American Enka Administration Building (1959), now known as the Enka Campus of Asheville-Biltmore Community College; the Music House at Asheville School (1938); the Parkway Office Building wing in the former Memorial Mission Hospital (1932); and the Interchange Building, formerly the Latta Nurses Home (1929), in conjunction with his father.

Tony Lord died in 1993 at the age of ninety-three.

24. THOMAS WOLFE MEMORIAL

This handsome Victorian-era house at 48 Spruce Street, built in 1883, is asymmetrical in plan and elevation and typical of the Queen Anne style sweeping the country from 1870 to 1910. Glowing from its yellow weatherboarding siding, white trim and blue-hued slate-shingled roof, the two-story, multi-gabled timber-frame structure comes alive in the sparkling sunlight on a soft summer day.

Julia Wolfe, the mother of author Thomas Wolfe, purchased the seventeen-room boardinghouse—previously named the Old Kentucky Home—in 1906 and, in 1916, embarked on an expansion project, which Wolfe described in his 1929 autobiographical novel, *Look Homeward Angel*:

> [She] *had made extensive alterations; she had added a large sleeping-porch upstairs, tacked on two rooms, a bath and a hallway on one side, and extended a hallway, adding three bedrooms, two baths, and a water closet on the other. Downstairs she had widened the veranda, put in a large sun-parlor under the sleeping-porch, knocked out the archway in the dining room, which she prepared to use as a big bedroom in the slack season,*

scooped out a small pantry in which the family was to eat, and added a tiny room beside the kitchen for her own occupancy. The construction was after her own plans, and of the cheapest material: it never lost the smell of raw wood, cheap varnish, and flimsy rough plastering, but she had added eight or ten rooms at a cost of only $3,000.

A front-facing bracketed gable, highly ornamented with fish-scale shingles, sits atop a two-story bay. A one-story porch, supported by bracketed square posts, wraps around the side and is topped by a metal roof with standing-seam joints. Windows have molded hoods supported by scroll brackets, with the upper sashes containing a series of small stained-glass lights. A modillion (scroll bracket) cornice begins at the bay window and wraps around the house.

Julia lived in the house until her death in 1945, at the age of eighty-five. The Thomas Wolfe Memorial Association purchased the house from her heirs in 1949, opening it as a museum. The City of Asheville took control of the house in 1958, and the North Carolina Department of Cultural Resources acquired final control in 1975. The house was designated a National Historic Landmark in 1973.

In the early hours of July 24, 1998, the twenty-nine-room house was set ablaze by an unknown arsonist. Quick response by the Asheville Fire Department limited the damage to 30 percent destroyed and 70 percent damaged but restorable. Rebuilding the house to its original 1916 condition required painstaking research, attention to detail and the need to acquire significant funding.

In 2004, six long years after the fire, the beauty of the house was fully restored and is now on display. Visitors can once again enjoy the house so vividly characterized as "Dixieland" in *Look Homeward Angel*.

Thomas Clayton Wolfe, considered to be one of America's greatest writers, was born in Asheville, North Carolina, in 1900. He graduated from the University of North Carolina–Chapel Hill in 1920 and continued his education at Harvard University, where he earned a master's degree in 1922. After graduation, Wolfe traveled to New York, where he obtained a teaching position at New York University. Following less-than-enthusiastic receptions for his plays, Wolfe turned to the novel form, penning his highly successful and autobiographical *Look Homeward Angel*; the book was published by Charles Scribner's Sons in 1929 and edited by Maxwell Perkins, one of America's foremost literary authorities. Following publication of his second novel, *Of Time and the River*, Wolfe left Scribner's

Thomas Wolfe. *Courtesy of the Thomas Wolfe Collection, Pack Memorial Public Library, Asheville, North Carolina.*

to work for Harper & Brothers, where his last two novels, *The Web and the Rock* and *You Can't Go Home Again*, were published after his death in 1938.

Wolfe is buried in Asheville's Riverside Cemetery.

25. Scottish Rite Cathedral and Masonic Temple

The monumental Scottish Rite Cathedral and Masonic Temple rises at the intersection of Broadway and Woodfin Street like a giant fortress. Designed by the firm of Smith and Carrier in 1913, the four-story, red brick building with its limestone and gray brick trim still maintains its majestic appearance and stands in stark contrast to the surrounding neighborhood.

The first floor of the Broadway façade has a quarry-faced granite foundation laid in horizontal courses of varying heights. Horizontal recessing of brick at every fifth level, called rustication, evokes an appearance of sturdiness and impregnability to the building, and the Romanesque corbelled arched entrance of gray brick enhances the building's fortress-like appearance.

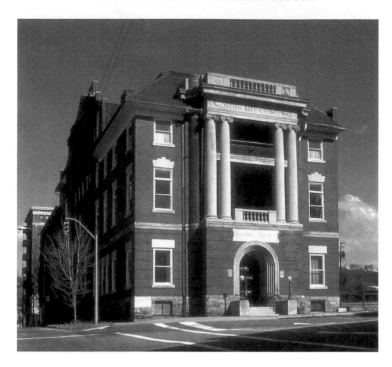

Towering over the entrance is a two-story portico embellished with paired Ionic columns reminiscent of Beaux-Arts styling. The Ionic entablature displays "Scottish Rite Cathedral" chiseled in granite, while overhead an attic story of urn balusters is flanked by the Masonic square and compass and the Masonic two-headed eagle, the best known symbol of the Scottish Rite of Freemasonry. Capping the front section of the building is a red-tile hip roof. On the Woodfin Street side, the roof over the center section of the building is gable-shaped. Under it, a blind arch is divided by five pilasters, with an ornamental band of bricks defining the curve of the arch.

The building's designers, architect Richard Sharp Smith and engineer Albert Heath Carrier, joined forces in 1906 to form the firm of Smith and Carrier, where together they created a heritage of architecture in Western North Carolina that includes over seven hundred buildings.

The Beaux-Arts style of architecture is classical in nature and was taught at the École des Beaux-Arts. This was a favored style for American architects from 1880 to 1930 and was mainly used for monumental public buildings such as courthouses, museums, libraries and banks. Richard Morris Hunt, Smith's mentor and the first American to attend the École des Beaux-Arts, popularized the Beaux-Arts style in the United States. An excellent example

of this style is the Fifth Avenue façade of New York's Metropolitan Museum of Art, designed by Hunt and his son Richard Howland Hunt and built from 1893 to 1902.

RICHARD SHARP SMITH AND ALBERT HEATH CARRIER

In 1890, Richard Morris Hunt, architect of George Vanderbilt's luxurious mansion under construction near Asheville, assigned a little-known thirty-seven-year-old architect named Richard Sharp Smith to be the on-site supervising architect. With that one act, the future architectural history of Western North Carolina dramatically changed. Smith, individually and later in partnership with Albert Heath Carrier, would go on to create over seven hundred unique and stylistically diverse domestic and commercial buildings for Asheville and the surrounding area.

After immigrating to the United States from Yorkshire, England, in the early 1880s, Smith worked for a short time in Evansville, Indiana, before moving to the New York office of architect Bradford Lee Gilbert, who later helped design Asheville's Manor Inn and Lodge, along with five of the subsequent cottages in Albemarle Park.

In 1886, Smith moved across town to the office of Richard Morris Hunt, the preeminent architect of the time. It is uncertain which projects Smith worked on during this period, but Hunt's practice was heavily involved with many Vanderbilt family commissions.

Once established at Biltmore, Smith took on supervisory duties that included weekly reports to Hunt on the weather, the projects inventory of materials and personnel decisions. He participated in the design and construction of several auxiliary buildings on the estate, and in 1892, he designed the Young Men's Institute Building in Asheville. Upon completion of the Biltmore House in 1895, Smith remained in Asheville to begin a private practice the following year. His office was located in the three-story Paragon Building on the corner of Patton Avenue and Haywood Street, which was demolished in 1969 and rebuilt as the Wachovia Bank building. Smith advertised his intention for a private practice in the September 5 edition of the *Asheville Daily Citizen* followed by a listing in the 1896–97 City Directory, as shown below:

R. S. SMITH, ARCHITECT, PARAGON BUILDING. Eight years with the late Mr. R. M. Hunt. Six years Resident Architect for G. W. Vanderbilt, Esq., Estate and New Residence, Biltmore, N. C.

Initially, much of Smith's work involved projects for Vanderbilt in Biltmore Village, including the development of several rental cottages, a post office, the Biltmore School, the Clarence Barker Memorial Hospital and Dispensary and a commercial-retail unit located on the plaza. The publication of Smith's *My Sketch Book* in 1901 listed his major work in the Asheville area, including several rental cottages for Vanderbilt located on Vernon Hill, a part of the township of Victoria, a fashionable suburb of Asheville that was incorporated in 1887 and became part of Asheville in 1905. The area is the present site of the Asheville-Buncombe Technical Community College campus. The sole remaining example of the cottages Smith built on Vernon Hill, Sunnicrest, is typical of his work there and in Biltmore Village; it features a Tudor-style façade containing half-timbering, pebbledash and brick quoining. The building now serves as the college's center for Business and Industry Services.

Between 1896 and 1906, Smith designed the Vance Monument (1896) honoring Zebulon Vance, two-time governor of North Carolina, and several residences in the Montford area, including the Ottis Green House (Black Walnut Inn) and the Dr. Charles S. Jordan House (Inn on Montford), both in 1900. North of downtown, in the upscale neighborhoods of Chestnut and Liberty Streets, Smith completed the Annie West House in 1901; four rental houses for Dr. J.E. David; and the Dr. H.S. Lambert House around 1900. Grace Episcopal Church in north Asheville was completed in 1905.

With the addition of Carrier as a partner in 1906, the firm became Smith and Carrier. Their Asheville accomplishments included the Legal Building (1912), one of the earliest uses of reinforced concrete; the Elks Building (1912), which now houses Malaprops Bookstore; the Scottish Rite Cathedral and Masonic Temple (1913), of which Smith was a member; the Eagles Building (1914), which now houses the WCQS radio station; St. Mary's Episcopal Church (1914), of which Smith was a member of the vestry; and the William Jennings Bryan House in the Grove Park neighborhood (1917). The 1923 Loughran Building, Smith and Carriers' last project, was deemed, at six stories, to be one of Asheville's first skyscrapers. Developed in the Commercial (Chicago) style of that period, it had the distinction of being the first building in Asheville to utilize an all-steel framing system. Denton's Department Store was its first occupant.

Smith's distinctive trademark style, thought to be derived from his work with Hunt at Biltmore, incorporated much of what is called English vernacular, including half-timbering, pebbledash wall finishes (pebbles imbedded into stucco), brick quoining at the doors and windows and gable dormers. The

Cathedral of All Souls in Biltmore Village, designed by Hunt, is an excellent example of this style. While many of Smith's buildings conform to this style, others exhibit a range of styles, including Queen Anne, Colonial Revival, Renaissance Palazzo and Commercial. Smith was a master craftsman confident in his ability to deliver in any style imaginable.

In the late 1890s, Smith married Isabel Cameron, a member of Vanderbilt's household staff. They built a lovely Colonial Revival home at the end of Chunn's Cove, where they raised a family of two girls (Emily and Sylvia) and two boys (W. Hampden and Richard Sharp Smith II).

In the July 23, 1957 issue of the *Asheville Citizen-Times*, Nancy Brower relates that there was much to be said of Smith's personal style:

> *His daughters Sylvia Schmidt and Emily White said he was "immaculate in his dress, almost prim." He dressed in tailor-made suits of British tweed. His tailor always made two pairs of trousers because of the long hours Smith spent seated at his drawing board. The vested suits were complemented by matching English walking caps. Smith wore the cap when driving to building sites in his pony cart. On more formal occasions he wore an English derby... He was never seen without his cane... The cane was strictly an accessory as much a part of his attire as the neckties he chose with such care... A small chestnut horse named Rowdy pulled his pony cart, which was attended by a small boy as footman. Town youths vied for the job.*

Smith died in 1924 at the age of seventy-two at Meriwether Hospital (demolished), a private institution on Grove Street. His funeral was held at the Robert Lewis Funeral Home, a building designed by Smith and Carrier in 1922. The building is now the Buncombe County Courthouse Annex. Smith is buried in Asheville's Riverside Cemetery along with Isabel, Hampden and Richard Jr.

Carrier came to Asheville with his parents in 1884 from Michigan. His father, Edwin Carrier, was a prominent developer in West Asheville, owner of the Sulpher Springs Hotel and promoter of an electric railway from the hotel to Asheville. The Historic Resources Commission's publication *An Architect and His Times: RICHARD SHARP SMITH* provides a brief summary of Carrier's life and achievements:

> *Carrier attended the Davis Military School in Winston-Salem, North Carolina, and Ravenscroft School for Boys in Asheville. Before joining Smith, he worked at the Brown and Northup Hardware Store as well as*

with his brother Ralph in the lumber business in Duplin County, North Carolina...After Smith's death, Carrier finished the projects they had started and became an inventor. He had numerous patents to his credit including a pivoted casement window adjuster used for years by General Motors, a palmetto wall board and a cultivator used by the International Harvester Company.

Carrier died in Asheville on May 19, 1961, at the age of eighty-four, and is buried in Riverside Cemetery.

Over four thousand original architectural drawings by Smith and by Smith and Carrier are in the collection of the Asheville Art Museum, a gift of the Historic Resources Commission. A grant allowed these valuable documents to be digitally transferred, and they are available for research in the North Carolina Collections at Pack Memorial Library, along with three volumes of carbon copies of Smith's correspondence from 1893 to 1906. Copies of Smith's *My Sketch Book*, edited by S.J. Fisher, published in 1901, are also available for viewing.

26. HAVERTY FURNITURE BUILDING

In 1928, the Haverty Furniture Company hired local architect William Henry Lord to design a four-story multiuse building on Haywood Street for office rental and retail trade. The first floor, initially used for furniture sales, featured a façade composed of chamfered limestone blocks, while the upper floors were finished in cream-colored brick. At each corner is a stylized Greek figure representing Pegasus.

The upper floors are three bays wide. The triple windows in each outside bay have continuous limestone sills and lintels, with the lintels being decorated with diamond-shaped fretwork. Above the lintels in the three bays are rectangular sections of depressed brick. Brick pilasters define the building corners and are topped with fretwork and geometric shapes. An impressive gabled parapet is decorated with various fretworks of chevrons and other stylized geometric patterns. This pattern continues to the edge of the building, under which a saw-tooth pattern continues across the width of the building. The corners and center of the gable are decorated with various forms of wildlife.

The building now houses a retail business on the first floor and condominium apartments on the upper floors.

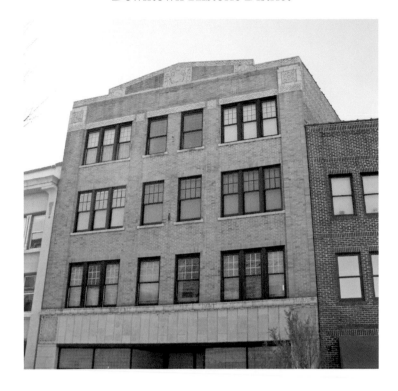

William Henry Lord came to Asheville from Syracuse, New York, in the late 1890s and quickly became one of the city's leading architects. Among the buildings that he designed were David Millard High School (1919, now demolished), Mission Hospital (1913, now the Park Place Office Building) and the E.D. Latta Nurses Home (1929, now the Interchange Building). He also designed various buildings for the Asheville Normal and Teachers College, which occupied the present site of Memorial Mission Hospital. Lord was killed in an automobile accident in 1933.

27. CASTANEA BUILDING

William J. East designed this striking three-story commercial brick building in 1921. Built for Julian Woodcock, the building was named after a former family plantation near Charlotte. Located on Haywood Street, the building is notable for its variety of orange and brown brick patterns creatively arranged. Deeply inset windows, of yellow trim, emphasize brick piers spaced between the windows. Brick corbelling at the top and bottom of each pier represents a column with a capital and base.

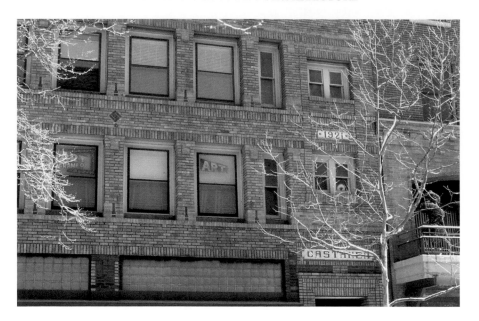

Lintels over the windows are set in a soldier course (bricks set in a vertical position), while a sailor course (bricks set horizontally) defines the windowsills. The first-floor shop fronts are original, with condominiums located on the second and third floors. Over the front entrance, the title "Castanea" and the year "1921" are set in glazed mosaic.

W.J. East came to Asheville around 1912 from Pennsylvania. In addition to the Castanea Building, he designed the International Order of Odd Fellows Building on Ravenscroft Drive (1928) and the Princess Anne Hotel on East Chestnut Street (1924).

28. Hotel Asheville—Malaprops Bookstore

Located on the corner of Haywood and Walnut Streets, this 1915 four-story brick commercial building was originally built for the BPO Elks under the guidance of Richard Sharp Smith, Asheville's most prolific architect. When the Elks relocated farther down Haywood Street in 1923, the Jenkins Hotel then occupied the building until 1932, when it was renamed the Hotel Asheville. From 1932 until the mid-1960s, Hotel Asheville provided a central location for the weary traveler.

For the next several decades, the building saw a smattering of businesses, followed by years of vacancy, until Malaprops Bookstore took

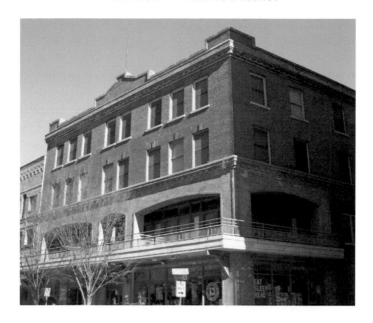

possession of the first floor in 1997. Upper-floor rooms were then converted into apartments.

The eye-catching second level is dominated by an arcaded veranda with a cantilevered balustraded balcony supported by four oversized diagonal brackets. A corbeled belt course with mutules carries around the building. The third and fourth floors, three bays wide, have double-hung windows with one-over-one lights and flat keystone arch lintels. The roof has a stepped gabled parapet flanked by block parapets at each corner.

Malaprops Bookstore, noted for its diverse clientele, cozy café and rare assortment of literature, remains one of downtown Asheville's most endearing establishments.

29. LOUGHRAN BUILDING

Richard Sharp Smith's ability to design in any architectural style is clearly evident in the six-story Loughran Building, in which he incorporated the design elements associated with the Commercial or Chicago style of architecture. The concept of how a tall building should look came from the fertile imagination of Louis Sullivan and was adopted by a group of Chicago architects in the late nineteenth century. The basic premise was that a tall commercial or office building should be compared to a classical column

with a base, shaft and capital—often described as a tripartite scheme. An unadorned façade, large rectangular windows, steel frame construction and a flat roof over a large cornice combine to define the elements of this style and are evident in the Loughran Building.

Completed in 1923 and located at the southeast corner of Haywood and Walnut Streets, the six-story building—widely considered to be one of Asheville's first skyscrapers—is composed of a two-story base beneath a four-story shaft capped by a plain frieze and large overhanging cornice. The base contains a deep-set entrance of display windows flanking two double-leaf glass entrance doors and bordered by elegant oak woodwork. A large signage board, bordered by deep-set black tiles, is situated over the entrance and under a second-story picture window flanked by paired double-hung windows. The end of the second-story base and the beginning of the four-story shaft is dramatically defined by a beautifully sculpted terra cotta cornice and plain frieze, which carries around to the Walnut Street (north) face of the building.

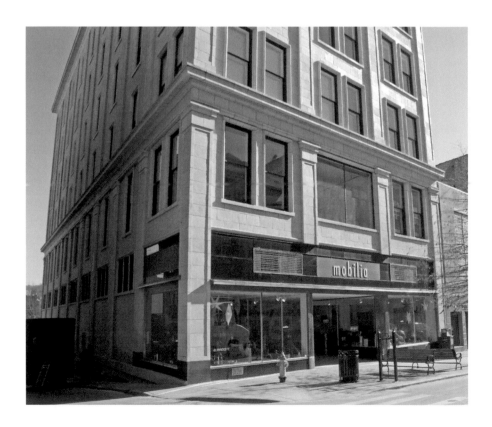

The four-story shaft, three bays wide, contains paired rectangular double-hung windows with one-over-one lights, and is divided by recessed panel piers capped by plain capitals. The front façade and the first bay on Walnut Street are composed of terra cotta–faced ashlar block.

The eight bays of the Walnut Street façade are divided by terra cotta piers on the first two floors and brick piers on the upper four floors. Each bay on the first two floors contains a triple window, providing usable light and abundant wall space for retail applications, with a rectangular double-hung window above for offices. Principal windows throughout are rectangular one-over-one double hung with one-over-one lights and molded terra cotta sills and surrounds.

Currently, the first floor is utilized as retail space, while the remaining floors have been rehabilitated for condominium usage.

The decade of the 1920s saw an upward swing in the Asheville real estate market, promising an economic upturn, thus prompting major development in the construction of high-rise buildings. Closely following construction of the Loughran Building in 1923 was construction of the thirteen-story Jackson Building and the attached eight-story Westall Building in 1924. In rapid succession there followed the fourteen-story Battery Park Hotel in 1924; the seven-story New Medical Building, located on the corner of Walnut and Market Streets, in 1925; the eight-story Flatiron Building in 1926; the Asheville-Biltmore Hotel (Altamont Apartments) in 1926, located at the corner of Woodfin and Market Streets; the four-story Kress Building in 1927; the eight-story City Building of Asheville in 1928; the seventeen-story Buncombe County Courthouse in 1928; and the eight-story Public Service Building in 1929 to close out the decade.

Frank Loughran arrived in Asheville in the late 1800s and immediately immersed himself in the business and civic affairs of Asheville. Having purchased several hotels and related businesses, Loughran further established himself in the community with the development of numerous residential and commercial properties. He was the president of Asheville's first Building and Loan Association, president of the Asheville and Buncombe County Good Roads Association and an active participant in the formation of Smoky Mountain National Park.

Loughran died in 1952 at the age of ninety-four and is buried in Riverside Cemetery.

30. WOOLWORTH BUILDING

F.W. Woolworth, a general merchandise store, opened for business on Haywood Street in 1939. The building is three stories tall, with a façade of cream and orange terra cotta. Asheville architect Henry Gaines designed the building using elements of Art Deco styling in the roof parapet and in low-relief motifs of plants and fountains centered over the upper-story windows.

In 1965, a major renovation was undertaken in which the lunch counter was enlarged to accommodate eighty customers and redecorated to include booths with leather seats. In 1993, the store closed, but in 2002 it was renovated and reopened with booths and studios for local artists to display their merchandise. The soda fountain was reactivated in 2004.

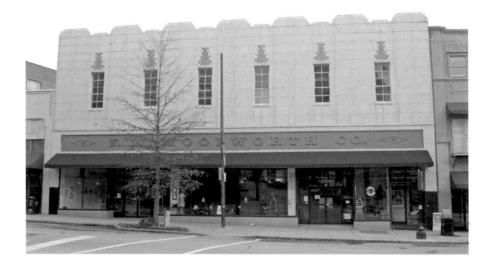

In 1878, Frank Winfield Woolworth opened his first store in Utica, New York. It was one of the first five-and-dime stores, in which merchandise was displayed in the open and customers could touch and select items without help from a clerk. The store failed within a year, but being persistent, Woolworth opened another store in Lancaster, Pennsylvania, the following year, and that success led to the eventual establishment of one of the largest department store chains in the world. Competition eventually eroded Woolworth's market share, however, and in 1997 the remaining stores operating as Woolworth's closed their doors.

Woolworth's early success led him to hire architect Cass Gilbert to design a sixty-story skyscraper in New York City. Initially costing $13.5 million and paid for with cash, the Gothic-style Woolworth building was dubbed the "Cathedral of Commerce." It was the tallest building in the world from its completion in 1913 until 1930.

31. FLATIRON BUILDING

Upon opening in 1926, the Flatiron Building became the center of the professional community. Quickly occupying office space, according to the City Directory, were physicians, dentists, architects, attorneys, realtors and insurance agents. Located at the corner of Battery Park Avenue and Wall Street, the central location made it convenient for residents of Asheville. Radio station WWNC occupied the penthouse in 1928. In 1939, the station moved to the new Asheville-Citizen Times building on O. Henry Avenue.

A 1990 designation report from the Asheville Historic Resources Commission describes the Flatiron Building in the following way:

> *The Flatiron Building, essentially unchanged from its original design, is an excellent example of a Commercial Classical Revival structure. Designed by Asheville architect Albert C. Wirth and built by prominent 1920s developer L.B. Jackson of quality materials. Classical details abound throughout the building; with touches of the elements and forms of the Art Deco and Sullivanesque styles. The division of the building into three specific areas, the storefronts, the intermediate floors, and the roof also displays a knowledge and use of the Sullivanesque style also gaining in popularity in the first part of the twentieth century.*

Louis Sullivan (1856–1924) received credit for the first successful solution to the architectural problem of what a tall building should look like. Sullivan's masterful solution is evident in his 1891 Wainwright Building located in St. Louis. In the Wainwright Building, all the elements of the form of modern skyscrapers were developed. Sullivan's concept, as defined in his 1896 magazine article titled "The Tall Office Building Artistically Considered," was to isolate the three main functions of an office building, with each function requiring a different façade treatment. The first two floors would contain shops and office space. The second level of offices, because of their identical function, was to have similar wall

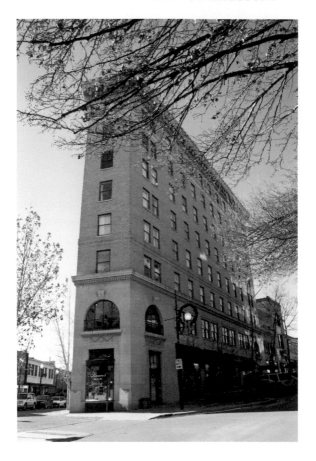

treatments. The final or top level would be for service and maintenance. This concept can be compared to a classical column having a base, shaft and capital.

The classically detailed Flatiron Building incorporated all of these design elements. The first two floors are of limestone ashlar and house retail shops and office space. The main façade faces north on Battery Park Avenue. Arched windows at each end of the building divide into eight lights. Below each of these windows is a panel of garland swags framed by triglyphs and topped by dentil molding under a limestone cornice. A scroll ornament tops each window. Classical detailing is evident over each first-floor storefront in the form of panels containing swags divided by a cartouche.

A limestone belt course caps the second floor and visually separates it from the tan brick upper or intermediate offices. Below the windows of the top floor, the architect has placed a rounded limestone belt course, with decorative carved panels placed between each window. The grand design

of the cornice incorporates dentil molding and mutules of limestone and is topped by a copper parapet.

The flatiron name derives from the shape of a clothes iron, which was flat on the bottom and made of cast iron. The Urban Trail created a seven-foot-tall replica of an early flatiron and located it between the Flatiron Building and the Miles Building.

32. Miles Building

In 1901, Richard Sharp Smith built a three-story brick commercial building at the corner of College and Haywood Streets for Frank Coxe, local real estate developer and builder of the 1886 Battery Park Hotel. Known as the Asheville Club, it was purchased from the Coxe estate, remodeled in 1925 and then renamed the Miles Building.

The building is beautifully detailed with white-glazed terra cotta trim. Retail space is located on the first floor, and offices occupy the second and third floors. Floor levels are defined by a belt course of brick above the first and second floors. A terra cotta frieze with dentil molding is highlighted above the second floor. A classical baroque cornice highlights the upper level. Horizontal terra cotta strips are used throughout to break up the brick courses, thus giving the illusion of rustication.

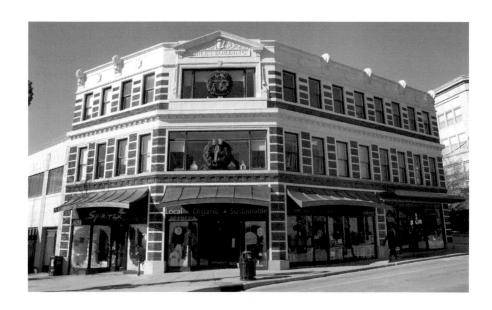

The main entrance is topped by a third-story pediment of solid terra cotta. Within the pediment or tympanum a cartouche is surrounded by stylized floral motifs, with the building's name placed directly below in low-relief letters. The pentagonal building plan wraps around to Wall Street, creating another richly embellished entrance. The architect is unknown. The building was named after local businessman Herbert D. Miles, who died in 1958 at the age of ninety-one.

The April 9, 1958 edition of the *Asheville-Citizen* described Miles's life as follows:

> *Mr. Miles had been in the hotel and real estate business here for some 45 years, having come to Asheville in 1913 because of the health of his wife. In 1923, Mr. Miles and Julian A. Woodcock Sr. erected the George Vanderbilt Hotel, and Mr. Miles served as president of the firm that operated the hotel. The Miles building on Haywood, Wall and College Streets was acquired by Mr. Miles from the Coxe holdings and the structure was remodeled and given the name it now bears.*
>
> *Pritchard Park was a creation and dream of Mr. Miles. He helped push a bill in Congress to acquire it for the city after the old Asheville Post Office was razed. Through a gift of property by Mr. Miles as president of the George Vanderbilt Hotel Co., the City Auditorium became a reality.*

A Romanesque brick post office built in 1892 by Peter Demens previously occupied the Pritchard Park area. The building was razed in the early 1930s.

The George Vanderbilt Hotel, originally built in 1924, was converted to apartments in 1969 by a nonprofit organization to provide housing for the elderly. The hotel's ornate Neo-Georgian façade was stripped down to the metal frame and rebuilt with an exterior wall of tan brick. Now known as the Vanderbilt Apartments, the building is located next to the Civic Center on Haywood Street.

33. TENCH AND FRANCIS COXE BUILDING

The lightness and delicacy of Art Deco detailing is manifested in this 1930s façade designed by Asheville architect Henry Gaines. Located across the street from Pritchard Park at 20–22 College Street, the two-story terra cotta–faced structure is named for two of developer Frank Coxe's sons. The building is divided into four bays, each one flanked by fluted pilasters. Atop each pilaster

is a circle circumscribing a feather motif, surmounted by low-relief stylized depictions of erupting fountains. The second-floor casement windows are topped by a series of low-relief panels portraying tetrahedrons (pyramids) and ziggurats. Retail establishments occupy the first and second floors.

Frank Coxe, a major landholder and developer in Western North Carolina, was born in 1839 to Jane and Francis Sydney Coxe in Rutherfordton, North Carolina. His grandfather, Tench Coxe (1755–1824), was assistant to Alexander Hamilton, secretary of the treasury during George Washington's administration. Upon graduation from the University of Pennsylvania as a civil engineer, Frank entered the family's lucrative coal mining business in Pennsylvania and then served a short stint as a Confederate officer in the Civil War. In the early 1880s, he moved to Charlotte to become president of the Commercial National Bank.

Coxe was instrumental in the Western North Carolina Railroad's successful completion of a route to Asheville in 1880, serving as both major stockholder and vice-president. Realizing that the area was ideal for northerners seeking escape from harsh winters and people from the Deep South seeking relief from oppressive heat and malaria, Coxe saw the need for a first-class hotel. In 1886, he opened one of the finest, most modern hotels in the Southeast, called the Battery Park Hotel. With the opening of the railroad to Asheville and the completion of the Battery Park Hotel, Asheville became one of the most sought-after places in the Southeast.

Coxe continued to influence the development of downtown Asheville as president of the Battery Park Bank and with the improvement of his properties along Coxe and Patton Avenues and College Street. He established a home at the Green Rivers Plantation in Rutherford County, North Carolina, where he died in 1903. He is buried in the city of Rutherford.

Francis and Tench Coxe, following in their father's footsteps, continued family involvement in land development and the banking industry while at the same time maintaining their civic-minded leadership in expanding the fortunes of Asheville. Francis died in 1906 at the age of thirty-nine, and Tench died in 1926 at the age of fifty-one. Tench was noted for his construction of a four-story, eighteen-room, English-style mansion at the far end of Montford Avenue. Called the Klondyke, the house remained in the family until 1947, when it was sold. The house passed through several owners until 1970, when it was demolished to make room for a public housing project, appropriately named Klondyke Homes.

Architect Henry Gaines graduated from Clemson University in the early 1920s and came to Asheville around 1925. His early architectural career was one of limited success, forcing him to accept door-to-door work selling the apple juice product Kings Maelum. However, after accepting a remodeling job for the Fernihurst House—now part of Asheville-Buncombe Technical Community College—he was able to resume his architectural career. His works include residential designs in the Tudor and Colonial styles, several buildings for Mars Hill College, the former Asheville Coca-Cola building on Biltmore Avenue (now part of Mission Hospital), the Glen Rock Hotel on Depot Street, the Crane Building on Battery Park Avenue and the Woolworth Building on Haywood Street. From 1932 to 1970, he worked extensively with Mars Hill College as its architect.

During World War II, Gaines joined five other architects to form the architectural firm of Six Associates. In his autobiography, Gaines describes the firm's formation:

> *Building materials were rationed and were available only for defense work. However, the defense effort was requiring a surge of military building. I began contacting the Engineer Corps, the Navy and the Air Force. Everywhere I received the same question and the same answer: "How many people do you have in your organization?"*
>
> *"Eight," I would reply.*
> *"Too small a force to handle our rush projects," was the answer.*

The other architects and engineers in our area were facing the same problem and receiving the same answer. Some time before, a group of us had collaborated on a public housing project, so the thought occurred to us, "Why not pool our organizations?" So six of us—Erle Stillwell, Charles Waddell, Tony Lord, Bill Dodge, Stewart Rogers and I—had lunch at the S&W Cafeteria and agreed to pool our operations and make a united effort to obtain some defense work. This combination produced an organization of about forty people, and since there were six of us, we thought "Six Associates" would be an appropriate name.

Henry Gaines died in 1986 at the age of eighty-six.

34. PUBLIC SERVICE BUILDING

The steel-frame, American bond, red brick Public Service Building is a masterpiece of Neo-Spanish Romanesque architecture. Designed in 1929 by the firm of Beacham & LeGrand of Greenville, South Carolina, the eight-story structure, located at 89–93 Patton Avenue, incorporates Louis Sullivan's vision that a tall building should be compared to a classical column with base, shaft and capital.

At street level, two Romanesque arched entryways contain detailed sections—called voussoirs—

that incorporate low-relief carvings of animals, griffins and floral motifs. The arch ends with a richly detailed sculpture—called an impost—containing acanthus leaves surrounding a richly detailed face.

The two-story granite base contains retail shop fronts over which the architects have placed a low-relief nameplate with "1929" centered between two sea serpents. Panels of red and green terra cotta tiles divide the four second-floor double-hung windows. End

windows at the same level are surrounded by brick inserts, with balconets that contain low-relief carvings. The uppermost window corners are low-relief depictions of *Leda and the Swan*, the mythological story of Helen of Troy, her brothers and their conception.

The metal-framed awning-style windows, rising through the third and seventh floors, have spandrels laid in header bond. The top story of the building—the capital—is a veritable explosion of polychrome terra cotta, geometric shapes and architectural details. Four arches, circular windows, imposts of acanthus leaves and rope moldings dominate the center section. The circular windows are trimmed with egg and arrow molding. Gold terra cotta crosses on a blue background above, and spandrels of shields below complete the dynamic effect. The corner sections contain rams heads, three-arched balconets and brick inserts.

The Public Service Building was built by the Tench Coxe estate for the Carolina Power and Light Company, which occupied the first three floors. The central location made the building attractive for professional and business tenants. Architects Henry I. Gaines and Beacham & LeGrand were some of the first to rent office space.

35. WICK & GREENE JEWELERS BUILDING

Originally designed as a Shell filling station around 1928 by W. Stewart Rogers, the building at the corner of Patton Avenue and Otis Street currently houses Wick & Greene Jewelers. With its central cubical massing and smaller

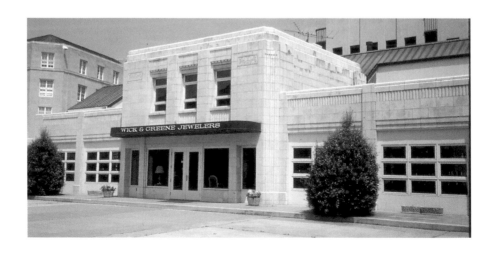

side wings, the building is similar in style to the federal courthouse on Otis Street and reflects the Art Deco movement popular during that period.

The triple windows over the main entrance are decorated with fluting above and below each window, while the two side wings contain a similar design above the windows called reeding, which is the reverse of fluting. Each corner of the middle block is concave and detailed with fluting. Art Deco panels at each corner of the main block depict stylized fountains.

William Stewart Rogers, a noted Asheville architect, was a graduate of Duke and Harvard Universities. He came to Asheville from Wilmington, North Carolina, in 1912 and in the 1940s became one of the founders of Six Associates, a major architectural firm in Asheville. Rogers retired in 1977.

36. Federal Courthouse

From 1929 to 1930, a new federal courthouse and post office was constructed on Otis Street on land that was donated by E.W. Grove. The architect was James W. Wetmore, working out of the Federal Supervising Architects Office in Washington, D.C. The post office relocated to a new building on Coxe Avenue in 1987.

The three-story building, constructed of ashlar limestone, is set on a granite water table. The main façade presents a symmetrical monolithic central entrance. Touches of Art Deco detailing are evident in the three low-relief carved panels over the massive front entrance and in the green

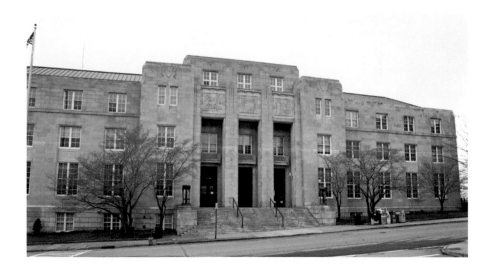

metal spandrels between the windows. The spandrels are embellished with an eagle surrounded by various geometric shapes. On each side of the main steps stand two six-foot-high classically designed verdigris braziers with Art Deco detailing.

From a historic perspective, the year 1929 is infamous for the stock market crash that occurred on Thursday, October 24—also known as "Black Thursday." Repercussions eventually filtered into Asheville and Western North Carolina. According to historian David Black:

> *On November 20, 1930, Asheville's largest financial institution, the Central Bank and Trust Company, with combined assets of over 52 million dollars, closed its doors. Five other Asheville banks closed almost immediately, with about two dozen western North Carolina banks following suit. Buncombe County, the city of Asheville and the public school system lost almost eight million dollars.*
>
> *The bank collapse nearly paralyzed Asheville. Within months the city commissioners resigned, the president of the Central Bank and Trust Company was sentenced to prison, and Asheville's mayor committed suicide. Building virtually ceased as the turbulent decade came to an end.*

When the city officials of Asheville decided to pay off the city's liabilities from the Great Depression, rather than defaulting as many other cities had, downtown was able to retain many of the buildings that we so treasure, thus keeping Asheville the unique place that it is today. From an architectural standpoint, it is ironic that the stock market crash, which devastated so much of the country, allowed Asheville to retain historic buildings that normally would have been razed for urban renewal projects. The last debt was paid off in 1976.

37. GROVE ARCADE BUILDING

Construction of the Grove Arcade, conceived as a shopping mall with a multistory office tower, was started in 1926 under the financial guidance of E.W. Grove, builder of the Grove Park Inn and the new Battery Park Hotel. The architect was Charles N. Parker. After Grove's death in January 1927, work was temporarily suspended until the following year, when Grove's estate transferred the property to Walter P. Taylor & Associates. Completed in 1929, with the office tower greatly reduced, the building stands as a fitting tribute to Grove, whom many call "the father of modern Asheville."

Brilliantly covered in ivory-colored granite blocks and glazed terra cotta elements, depicting Gothic and Tudor motifs, the structure, located at 1 Page Avenue, covers an entire city block. Utilizing the slope of the lot, Parker transformed the structure from two stories in the north to two stories plus a mezzanine level in the south. The cornice/parapet, containing heart-shaped terra cotta tracery, carries around the entire building, interrupted at each of the four barrel-vault entrances by panels containing the word "GROVE."

The north entrance features winged lions guarding twin ramps to the roof deck. The walls above the ramps contain stylized depictions of medieval laborers, including one for the architect Parker. Windows are the large display type on the first floor, double-hung windows with one-over-one sashes on the second and third floors and paired Diocletian windows topped with Tudor hood moldings in the tower.

In 1942, the United States General Accounting Office's Postal Accounts Division took possession of the building, removing the shop fronts and filling them in with brick, thus effectively closing the building off from the outside world. From 1951 until 1995, the National Weather Records Center occupied the building. In 1970, the name was changed to the National Climatic Center.

In 1994, the federal government transferred the Federal Building (Grove Arcade) back to the City of Asheville for the sum of one dollar. The National

Monument Act required the city to preserve and maintain the historical significance of the building, and in keeping with the law's regulations, particular care was taken during renovation to restore the integrity of the thousands of original terra cotta units. Under the direction of William Wescott, Asheville historic preservationist, strict guidelines were utilized for the structural stabilization, cleaning and restoration of the building. The original shop fronts that had been filled in with brick and glass block when the federal government took control were removed, and historic shop fronts were reinstalled.

Following completion of major rehabilitation, the City of Asheville instituted a long-term lease with the Public Market Foundation, under which the first floor is to provide space for retail trade and with the upper floors subleased to Progress Energy for tax credit use.

Opening with great fanfare in the fall of 2002, the newly renovated 270,000-square-foot building contains fifty-four public market spaces, forty-seven luxury apartments and twelve exterior day tables. An underground garage provides adequate parking spaces for residents and support staff.

Charles N. Parker came to Asheville from Ohio in 1904 and worked for the architectural firm of Smith and Carrier until 1918, when he opened his own office. After World War II, he worked primarily for Six Associates. Parker died in 1961 at the age of seventy-five.

The building was placed on the National Register of Historic Places in 1976.

38. BATTERY PARK HOTEL

In 1886, six years after the railroad came to Asheville, wealthy coal executive Frank Coxe built a magnificent Queen Anne hotel on a prominent hill overlooking Asheville. The hill, named Battery Porter for the Civil War cannons that were located there, covered twenty-five acres. The hotel, appropriately named Battery Park Hotel, quickly became one of the finest resort hotels in the South, and it was here that George Vanderbilt had his first glimpse of the surrounding beauty of the mountains.

By the 1920s, however, the hotel's best days were over, and it was then that E.W. Grove, a wealthy manufacturer of patent medicine, decided to purchase the hotel with the intention of tearing it down, leveling the hill and building a new hotel. The leveling of the hill became a time-consuming and labor-intensive project. Using steam shovels and hand tools for digging

and mules and wagons for hauling, it took twenty-one months—from December 1922 to August 1924—for the hill to be fully leveled, so long that the new Battery Park Hotel, construction of which had begun in 1923, was nearing completion as the work on the hill was ending. The hotel officially opened in September 1924. The earth that was removed from the hill was used to fill a ravine on the west side of Coxe Avenue.

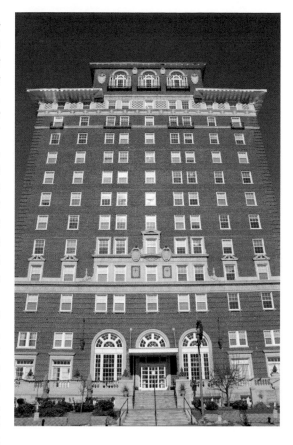

Grove selected New York architect W.L. Stoddart, a leading hotel designer of the period, to create the building. Stoddart's design, in the shape of a T, is constructed of reinforced concrete, faced with brick and trimmed with terra cotta and limestone. The building is fourteen stories tall and has 220 rooms, all of which face the street and have private baths.

The Neoclassical style popular for hotels in the 1920s divided the building into three horizontal parts: a three-story base, an eight-story central section and a three-bay penthouse above an elaborate cornice. The three-story base is defined by three large arched openings flanked by French doors. Pergolas with Ionic columns and classical urn balustrades flank the main level.

Topping the three-story base is a limestone frieze, or belt course, with various foliate designs in relief and dentil molding lining the top. Directly above the frieze over the main entrance are two cartouches of limestone located below a pedimented window, with sculptured designs lining each side. To the right and left of the cartouches are windows with swan's neck pediments, so called due to their sloping double S-shaped decorative elements. A small decorative element in the shape of an acorn defines the middle. The corners of the building are finished in decorative brick quoins.

Topping the eight-story main section is a limestone cornice decorated with shields and dentil molding, while directly above are eight sections of glazed terra cotta designs called diaperwork that exhibit patterns of diamonds and diagonal strips. The cornice and diaperwork continue to wrap around each side of the building. Large eave brackets support the right and left overhangs of the Mission-style roof.

The windows in the three-bay penthouse are bordered by double columns of Tuscan and Ionic design. Two large and two small cartouches complete a balanced effect.

Following E.W. Grove's death in January 1927, the property remained in the Grove family until 1955, when it was sold. The hotel was again sold in 1971, but due to expensive upkeep, it was closed the following year. In 1977, the hotel was placed on the National Register of Historic Places, and in 1978 it was purchased by Battery Park Associates Limited Partnership and converted, under the auspices of the U.S. Department of Housing and Urban Development, into 122 apartments for senior citizens. In 2004, National Church Residences purchased the property, implementing a $2.4 million renovation.

39. THE BASILICA OF ST. LAWRENCE

Walking up Haywood Street on a warm, sunny afternoon, visitors may stop and gaze with awe at the architectural wonder of the Basilica of St. Lawrence. The Spanish Baroque Revival church, completed in 1909, evokes thoughts of a culture from another time and country. This marvelous structure came about through the efforts of Rafael Guastavino.

Rafael Guastavino (1842–1908) came to America from Barcelona, Spain, in 1881, accompanied by his nine-year-old son. Establishing himself in New York, he found architects slow to accept his new method of building, called "cohesive construction." Through perseverance and presenting his ideas through magazine articles and competitions, his process slowly achieved acceptance in the architectural community. By 1889, his success allowed him to form his own company, the Guastavino Fireproof Construction Company.

Guastavino's special technique of using courses of lightweight tiles fastened together with Portland cement enabled him to construct vaulting that had the advantage of spanning large distances with a low rise that was self-supporting and completely fireproof. Construction projects were less expensive and faster to erect due to the Guastavino Company controlling

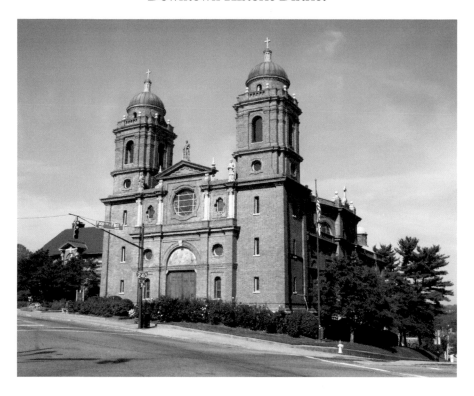

all aspects of construction. The company eventually held twenty-five United States patents.

Working closely with many of the most important architects throughout the country, the Guastavino Company was involved in the construction of over one thousand buildings, more than three hundred of which are located in New York and Boston. Notable among the New York structures are the Grand Central Terminal, the public market beneath the Queensborough Bridge, the U.S. Custom House, the Cathedral of St. John the Divine and the Great Hall of Ellis Island. In Boston, as Leland M. Roth notes, the vaulting of the Public Library was one of Guastavino's most important early successes:

> *Aside from the impressive integration of allied arts, the Boston Public Library was also significant for its widespread use of thin monolithic shell vaults for its flooring, a technique developed by the Catalan, Rafael Guastavino, who had recently arrived in the United States expressly to perfect his vaulting process. After 1890, Guastavino vaults were widely used to frame the various domical and vaulted forms popular in churches and public buildings before the depression of the 1930s. The exploitation of the Guastavino*

system indicates that McKim, Mead & White, among other traditionalist architects, used new technological methods to achieve the spaces they desired.

On the recommendation of Biltmore Estate architect Richard Morris Hunt, Guastavino came to work on the Biltmore Estate in the mid-1890s. He only worked there for several months, but during that time he created lasting images of his architectural expertise. The distinctive herringbone pattern of tile used by Guastavino is evident in the ceiling of the Main Gate lodge, the Winter Garden, the swimming pool and the loggia. Guastavino became entranced with the Asheville area and stayed to make it his home. He built a house in Black Mountain that is now demolished, but remnants of his kiln and wine cellar are still visible on the site, now the location of Christmount Christian Assembly.

While attending the small wooden Catholic church in Asheville, he became dissatisfied with the lack of available seating and proposed to build a new church. Starting in 1905, and working with Richard Sharp Smith, Guastavino designed a magnificent Spanish Baroque Revival church that stands at the corner of Haywood and Flint Streets. Considered one of the finest churches in North Carolina, it was listed on the National Register of Historic Places in 1978. The church became the thirty-fourth basilica in the continental United States when it was designated a Minor Basilica in April 1993.

The church, built of multihued brick laid in a Flemish bond pattern, sits on a foundation of quarry-faced gray granite. The church employs the cohesive construction method patented by Guastavino and contains a large, self-supporting oval dome measuring eighty-two by fifty-eight feet. Construction is such that no wood or steel is used in the building—the tower stairs are self-supporting.

The twin towers, topped with belvederes, were originally covered with tiles, but water leakage and protection of the tiles dictated that a copper covering be placed over the belvederes. Carved limestone trim and statuary throughout was done by Fred Miles. Topping the front gable is an image of St. Lawrence holding a feather and a gridiron, symbolic of his martyrdom. St. Lawrence is the patron saint of chefs and cooks. To the left is the figure of St. Stephen with stone and palm, and to the right is St. Aloysius Gonzaga. Over the front door is a polychrome terra cotta lunette depicting Christ healing the sick. Guastavino died in 1908, and his body is interred in a church crypt. His son, Rafael Jr., completed work on the church.

St. Mary's Church in Wilmington, North Carolina, similar in style to the Basilica of St. Lawrence, was designed by the father and son between 1907

and 1909. Construction began in 1909 and was completed in 1911. Other North Carolina buildings of interest by the Guastavinos include the Duke Chapel in Durham, the Jefferson Standard Building in Greensboro and the Motley Memorial in Chapel Hill.

Tours of the church are available after Sunday Mass or by appointment.

40. HANGER HALL HOUSE

Hanger Hall, located at 31 Park Avenue and formerly known as the Demens-Rumbough-Crawley House, is one of the largest and most highly decorated residences in Asheville. Positioned on a rise overlooking the French Broad River, the house is an eclectic combination of Queen Anne, Eastlake and Italianate styles.

The outstanding feature of the house, which is built of red brick in the American bond style, is the massive projecting multistory bay with a two-tiered wooden portion capped by multiple gables and supported by paired corner brackets. A five-sided, two-story bay projects from the base of the tower.

The porch extends from the tower and wraps around to the east; it is supported by thin turned posts under a highly decorated Eastlake-style frieze of spindles, pendants, circles and saw-tooth strips. The main entrance,

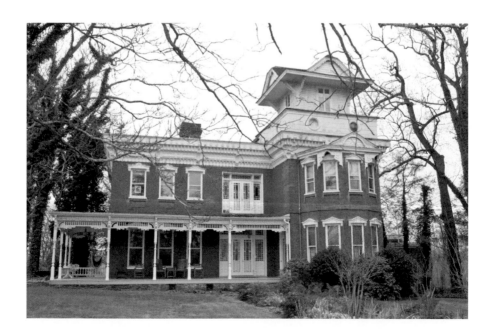

imitated on the second level, is composed of multi-pane double doors, bracketed transoms and matching sidelights. The Italianate style is evident in the pedimented hoods covering the double-hung windows on the first and second floors. The multilayered wooden cornice contains myriad detail, consisting of brackets, panels, pendants and medallions.

Construction of the house is attributed to Russian-born entrepreneur Peter Demens, who had been instrumental in developing the city of St. Petersburg, Florida, named after the Russian city where he spent part of his youth prior to arriving in Asheville around 1890. In Asheville, Demens quickly became involved in various construction projects, starting with the house at 31 Park Avenue and moving on to the 1892 Federal Post Office—now demolished but formerly located at the present site of Pritchard Park—and the 1892 Statesville Post Office and Courthouse.

After Demens left Asheville for California, the house was purchased by Colonel James H. Rumbough, owner of the Mountain Park Hotel in Hot Springs. Ida Crawley took possession of the house in 1919 and used it as an art and archaeological museum, called the House of Pan, until 1946. Following various owners, the Reverend Howard Hanger purchased the property in 1972.

The building was placed on the National Register of Historic Places in 1982.

41. RICHMOND HILL INN

The Richmond Hill Inn was a vivid testimony to the days when the center of social and political activity in Asheville revolved around a magnificent mansion located on a high bluff overlooking the French Broad River. The rambling thirty-room Victorian house—a combination of Queen Anne styling and classical elements—was completed in 1890 for diplomat and congressman Richmond Pearson and his lovely wife, Gabrielle. It was designed by James G. Hill, former supervising architect of the United States Treasury.

The asymmetrical multi-gabled structure was covered with weatherboard siding, and shingles were prominent in all of its gables. A porte-cochere attached to the beginning of the wide veranda wrapped around to the south. Opening onto the veranda were floor-to-ceiling windows with two-over-two sashes. Ornate scroll brackets attached to tapered posts supported the wide porch cornice, and beneath the hipped and gabled slate roof, a wide-paneled cornice carried around the house. The main entrance was composed of

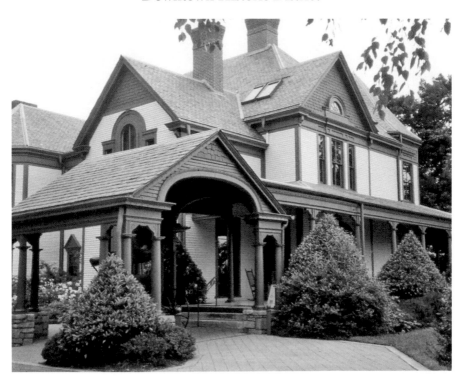

double-leaf paneled doors framed with a fanlight and full-length sidelights, both filled with intricately detailed geometric shapes. Although windows throughout were generally two-over-two sashes, the north façade featured several unusual configurations—a Palladian window above a triple window decorated with an oval head, a circular window and a steeply pitched pediment window. Three staggered windows topped with Tiffany glass defined the path of the grand staircase.

Richmond Pearson was the fourth of five children born to North Carolina Supreme Court Justice Richmond Mumford Pearson. After studying law under his father and being admitted to the bar, he was named U.S. consul to Belgium—a post he held until 1877. After serving two terms in the North Carolina legislature, Pearson was elected to the U.S. House of Representatives in 1895. President Theodore Roosevelt, a close friend, appointed him as U.S. consul to Genoa, Italy, in 1901, quickly followed by an appointment as ambassador to Persia in 1902. From 1907 to 1919, he was ambassador to Greece and Montenegro. After resigning from diplomatic service, Pearson returned to his beloved Richmond Hill and resumed his law practice. Pearson died in 1923 at the age of seventy-one; he is buried in Riverside Cemetery alongside Gabrielle, who died in 1924.

Aftermath of the early morning fire that consumed much of historic Richmond Hill Inn.

The house was put into the hands of a caretaker for the next twenty-seven years, while Pearson's two children, Thomas and Marjorie, traveled and worked around the world. Returning in 1951, the children opened the house to the public as a museum until Thomas's death in 1963. Marjorie closed the museum but continued to live in the house until her death in 1972. The house was then willed to a cousin, who held a public auction in 1974 to sell the estate's antiques and furnishings, followed by the sale of the house and grounds to North Carolina Baptist Homes, Inc. The new owners completed construction of a retirement center adjacent to the Pearson House in 1978. The Preservation Society of Asheville and Buncombe County worked tirelessly to preserve the mansion, which was being neglected and left to the ravages of time and vandalism.

In 1981, the house was sold for $1 to the Preservation Society, with the provision that it be moved within one year. A three-year fundraising drive ensued to raise $100,000 to cover the cost of moving the house approximately 650 feet to the east, where a seven-and-a-half-acre lot had been prepared.

The house sat unloved and in a sad state of disrepair, however, until 1988, when Albert Michel, president of the Education Center of Greensboro, purchased the property as a future conference center and bed-and-breakfast.

Opening in 1989, the rebirth of Richmond Hill as the Richmond Inn was a reminder of the glorious days of buggy rides, gaslights, southern elegance and midnight balls.

The building was placed on the National Register of Historic Places in 1977.

Sadly, on March 19, 2009, an early morning fire tragically destroyed over 50 percent of this historic structure.

Montford Historic District

Introduction

The historic neighborhood of Montford, a short walk north from downtown Asheville, incorporates a wonderland of architectural delights into its three hundred acres. A veritable candy store of styles, covering over six hundred residential and commercial structures, the neighborhood ranges from Queen Anne, Colonial Revival, Arts and Crafts and Shingle to Bungalow and Neoclassical. Notable among the many diverse styles included are multiple designs by Richard Sharp Smith and William Henry Lord, two of Asheville's premier architects.

Montford was originally incorporated in 1893 as a small village of approximately fifty middle-class entrepreneurs, professionals and retirees. During this period, the Asheville Loan, Construction and Improvement Company began purchasing large expanses of land in Montford for the purpose of residential development. Further work in the area was curtailed by the financial crisis of 1893 until Asheville philanthropist George W. Pack intervened with financial assistance, enabling the company to continue with its development plans. Trolley service to Chestnut Street and over to Cumberland had begun in the summer of 1891, and in 1896 the tracks were extended down Montford Avenue. The establishment of street patterns by 1896 confirmed the prospect of Montford as an up-and-coming suburb, with the city of Asheville annexing the area in 1905.

Up until the late 1920s, the majority of buildings in Montford were residential, but there were also several classically detailed apartment

houses, nursing homes and boardinghouses. A structure at the corner of Montford Avenue and Watauga Street that had originally been built as a residence was converted to a hospital in 1927 under the direction of Doctors Charles and Russell Norburn. In 1947, the hospital was moved to the property of the former Asheville Normal and Teachers College, where it operated as Norburn Hospital (Victoria Hospital) until its 1950 merger with Memorial Mission Hospital. Provisions of the merger allowed Memorial Mission Hospital to maintain control of the property, its present site.

Located within the geographical boundaries of the Montford area are two areas of special historical significance: Stumptown and Riverside Cemetery. Stumptown was an African American neighborhood of close-knit families bounded by Pearson Drive, Birch Street, Courtland Avenue and Riverside Cemetery. With over 250 residences, covering thirty acres, Stumptown existed from about 1880 until the early 1970s, when a federal urban renewal project cleared the area for the construction of a community center, tennis courts and a baseball field. Adjacent to the baseball field is the Hazel Robinson Amphitheater, a terraced hillside built in 1983 to house the Montford Park Players, North Carolina's longest-running Shakespeare festival. Performances began in 1973 at the municipal park located at the far end of Montford Avenue. George W. Pack donated the rolling, tree-lined park to the neighborhood.

Riverside Cemetery, located west of Pearson Drive and overlooking the French Broad River, was established in 1885 by the Asheville Cemetery Company. Covering eighty-seven acres of gently winding roads, the cemetery contains the graves of many prominent citizens of Asheville, including authors Thomas Wolfe and O. Henry (William Sidney Porter), as well as those of eighteen German sailors who were interned during World War I at Hot Springs, North Carolina. The City of Asheville took control of the cemetery in 1952 and continues to maintain it as a working cemetery.

Following a decline in the neighborhood from the 1960s throughout the 1980s, the residents of Montford, assisted by the Preservation Society of Asheville and Buncombe County, initiated a movement that placed the area on the National Register of Historic Places as a Historic District in 1977. In 1980, Montford was also designated as a Local Historic District by the Asheville City Council, thus giving the Asheville-Buncombe Historic Resources Commission (HRC), a fourteen-member advisory group, the "legal authority to review and regulate all proposed changes to the exteriors of buildings, man made structures and landscaping" in the district. In addition

Montford Historic District

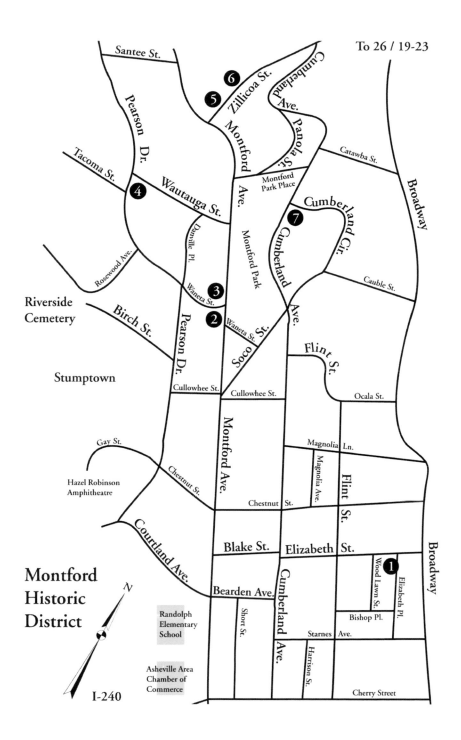

To 26 / 19-23

Santee St.

Zillicoa St.

Cumberland Ave.

Pearson Dr.

Tacoma St.

Wautauga St.

Montford Ave.

Danville Pl.

Panola St.

Montford Park Place

Catawba St.

Broadway

Cumberland Cir.

Rosewood Ave.

Riverside Cemetery

Birch St.

Waneta St.

Montford Park

Cumberland Ave.

Cauble St.

Stumptown

Pearson Dr.

Waneta St.

Soco St.

Flint St.

Cullowhee St.

Cullowhee St.

Ocala St.

Gay St.

Montford Ave.

Magnolia Ln.

Magnolia Ave.

Flint St.

Hazel Robinson Amphitheatre

Chestnut St.

Chestnut St.

Montford
Historic
District

N

Courtland Ave.

Blake St.

Elizabeth St.

Wood Lawn St.

Elizabeth Pl.

Broadway

Bearden Ave.

Cumberland Ave.

Bishop Pl.

Randolph Elementary School

Short St.

Starnes Ave.

Harrison St.

I-240

Asheville Area Chamber of Commerce

Cherry Street

to the Montford area, Biltmore Village, Albemarle Park and Saint Dunstans have also been designated as Local Historic Districts. Oversight by the HRC ensures that the character and integrity of these four neighborhoods will remain intact.

Much credit for the area's resurgence must also be given to the bed-and-breakfast industry, which, beginning in the 1980s, helped initiate a gradual return to respectability. Adding a touch of class and glamour to the area, the beautifully painted and immaculately landscaped homes became a stabilizing influence and invited the outside world to come and see the newly updated neighborhood. Today, Montford is one of the most attractive and sought-after places to live and build in Asheville. The continued addition of historic-style homes filling long-vacant lots further enhances the area's architectural diversity.

Sitting at the head of Montford Avenue is the newly built Asheville Area Chamber of Commerce, an excellent place for visitors to begin a tour of the area. The *Historic Montford Neighborhood Architectural Guide* lists in-depth information on many of the district's fine structures. Information on walking tours can be obtained at the visitors' desk. In addition to the houses covered, literally hundreds more can capture your fancy. It's a great way to stretch your legs and dazzle your eyes.

1. RANKIN-BEARDEN HOUSE

Located in the Montford Historic District, the Rankin-Bearden House at 32 Elizabeth Place was built in 1848 by William Rankin for his lovely wife, Elizabeth. The couple arrived in 1846 from Newport, Tennessee, where William was a highly successful businessman. William's wealth allowed him to purchase large tracts of real estate, forty-two acres of which was sold to the Asheville Loan, Construction and Improvement Company, developers of the town of Montford.

The two-story house, considered to be the oldest wood-frame house in Asheville, built on an American bond brick foundation, was built in the Greek Revival style and features clapboard siding and a low-pitched hipped roof. The massive porch, supported by decorative columns, features a molded, geometrically shaped balustrade with intricate scrollwork overhead. A fully developed second-floor balustrade sits atop the porch. The extensive cornice-soffit is supported by decorative brackets under a standing seam metal hipped roof vented by pedimented dormers.

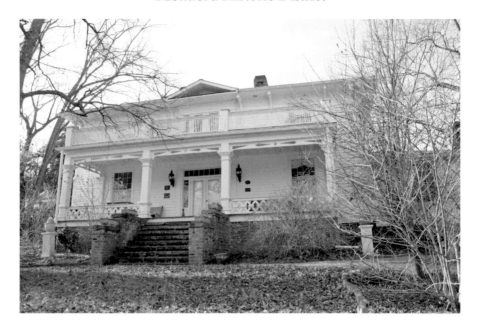

The main entrance is composed of double-leaf hand-molded doors flanked by sidelights under a multi-light transom. An entablature supported by Doric pilasters completes the design. Flanking the main entrance, and typical of the house throughout, are double-hung windows with twelve-over-twelve lights. Prior to 1900, a one-story bay, designed in the Italianate style, was appended to the south side of the house.

In addition to his business interests as one of the largest landholders in the area and operating a highly successful mercantile enterprise, William quickly involved himself in politics and public service. He was mayor of Asheville from 1855 to 1857 and Buncombe County commissioner from 1854 to 1868. He died in 1879 and is buried in Riverside Cemetery.

Elizabeth continued to live in the house, along with her daughter Amelia and her son-in-law M.J. "Joe" Bearden, until her death in 1908. Elizabeth Street and Elizabeth Place are named in her honor. Amelia continued living in the house following Joe's death in 1903 until it was sold in 1911. Joe Bearden's business interests included investment in the Asheville Loan, Construction and Improvement Company and owner of the MJ Bearden General Merchandise store (later Bearden, Rankin & Company). He partnered with Eugene Rankin to establish Asheville's first tobacco warehouse. Bearden Street is named in his honor. Joe and Amelia, who died in 1922, are buried in Riverside Cemetery.

Amelia's brother, James Eugene Rankin, following in his father's footsteps, involved himself in real estate, politics, public service, banking and the

mercantile business. He was a three-time mayor of Asheville. Rankin died in 1928 and is buried in Riverside Cemetery. Eugene Rankin Elementary School and Rankin Avenue were named in his honor.

In 2006, the Rankin-Bearden House was designated a local historic landmark.

2. LION AND THE ROSE BED & BREAKFAST

Guarded by two lions and painted a delightful rose color, the Lion and the Rose at 276 Montford Avenue combines elements of the Colonial Revival, Georgian and Neoclassical styles. Completed around 1896, this imposing structure sits on a stone foundation that supports a high basement.

The two-and-a-half-story house visually divides into three distinctive levels of architecture: a porch that spans the width of the first floor, a second-level bay window and an elaborate gabled dormer at the third level.

The porch rests on a series of paired Tuscan posts placed on quarry-faced stone pedestals. The bay windows above are double-hung and contain one-over-one lights. The third and dominant feature of the front façade is an elaborate dormer consisting of Tuscan columns supporting a plain entablature and pediment. Two double-hung windows with eight-over-

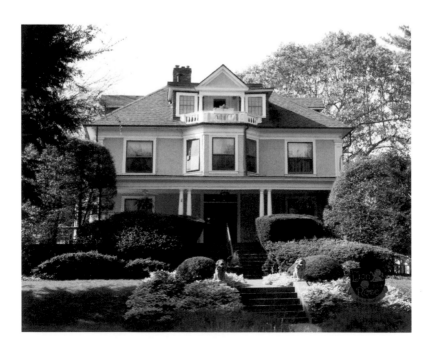

eight lights flank a single door that opens onto a balcony. An urn balustrade completes the classical composition.

Another beautiful piece of classical detailing is evident in the Palladian window centered on the pebbledash wall facing Waneta Street. Highlights of the window are four Tuscan columns, a distinctive keystone and a colorful stained-glass center section.

The first known residents of the house were Elmer and Charity Craig. They arrived from Wisconsin in 1896 in search of a healthier climate to revitalize Elmer's failing health. Elmer died in 1898, but Charity continued to live in the house until her death in 1913. Charity was prominent in the Women's Relief Corps, eventually becoming national president in 1888.

Charles and Ethel Toms moved into the house in 1913, and the oldest of their five children, Charles French Toms, was the basis for the character called Tom French in Thomas Wolfe's novel *Look Homeward Angel.*

In 1985, Jeanne Donaldson purchased the property, renovating it to its original magnificence and opening it as a bed-and-breakfast inn.

3. Black Walnut Bed and Breakfast Inn

The Black Walnut Bed and Breakfast Inn, located at 288 Montford Avenue, was formerly known as the Ottis Green House. The house is a combination of Shingle, Queen Anne and Colonial Revival styling that came from the drawing board of the talented Richard Sharp Smith.

Completed around 1900, this two-story structure incorporates features prevalent in many of Smith's eclectic designs. Notable is the use of pebbledash and half-timbering on the first floor, shingles on the upper floor, diamond-pane windows and Montford porch supports on stone pedestals. A small second-floor porch, called a minstrel's gallery, contains diamond-pane windows and Montford posts, which consist of square posts with flared brackets on each side and are commonly found in the Montford community. On the left, an elaborate gabled porte-cochere at the end of a shrubbery-lined driveway welcomes the weary traveler.

The main entrance features an oversized Dutch door, measuring three feet, nine inches wide by eight feet, two inches high and is divided into a diamond-pane upper section with paneling below. Diamond-pane sidelights over panels of pebbledash complete the balanced entrance. A multi-gable roof features flared gables, a conical roof tower and a shed dormer, reflecting

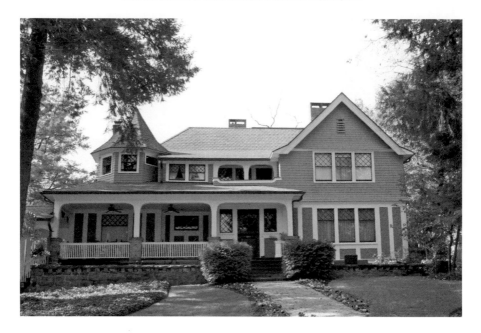

the eclectic style typical of Smith's designs. Eclectic architecture is a style that combines elements of several historical styles.

Ottis Green purchased the house in 1917 and lived there with his family until 1973, when he died at the age of ninety-eight. During his life, Green was actively involved in civic, spiritual, political and philanthropic work throughout Asheville and Buncombe County. He served as mayor of Asheville from 1931 to 1933 and led a successful drive to adopt the city manager form of government. From 1905 until 1956, he operated a hardware store on North Main Street (Broadway).

4. WRIGHT INN & CARRIAGE HOUSE

Located at 235 Pearson Drive in the Montford district, this highly ornamented house is one of the finest examples of Queen Anne styling in Asheville. Built around 1900, the two-and-a-half-story multi-gabled structure features weatherboard siding, a slate roof and wide bargeboards. Tuscan porch posts on paneled pedestals support a frieze of multiple spindles. Inset under the main gable is a multi-arched balcony with spindle frieze and curved balustrade. A wraparound porch connects to a side gazebo consisting of a conical roof, a spindle-and-bracketed-cornice and paired Tuscan porch posts supported by paneled pedestals.

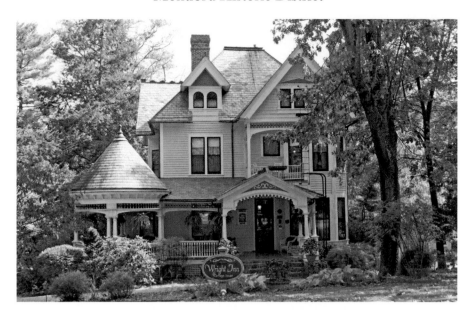

The house was built for Osella and Leva Wright, proprietor of the Carolina Carriage House. Following her husband's death in 1931, Osella, in need of increased income, opened her home to boarders. After her death in 1946 at the age of ninety-one, the house continued as a boarding establishment until 1970, when it became a private residence. In 1987, new owners, visualizing the magnificent house as a future bed-and-breakfast, began the work of transforming the building and its surrounding property to their original grandeur. In 1989, the house was listed as a Local Historic Landmark.

5. HOMEWOOD

Dr. Robert S. Carroll, founder of Highland Hospital, designed Homewood as one of the most unusual and creative buildings in the Montford area. Built in 1922 at 19 Zillicoa Street, with the addition of a medieval turret after 1925 and a music room in 1934, the building retains much of its original design.

Constructed of uncoursed stone masonry the asymmetrical structure with its crenellated polygonal tower evokes days of medieval knights and fair damsels. The approach to the recessed main entrance is through a large basket arch capped with a massive keystone. The deep-set casement windows feature flat arches and keystones. A flying buttress on the south side adds the final touch to the magnificence of English Norman architecture.

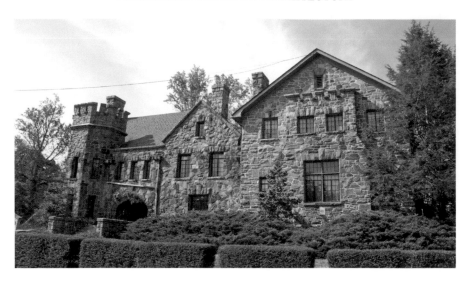

Carroll came to Asheville in 1904 to establish a sanitarium. By 1906, he had founded Highland Hospital as a treatment center for psychiatric care. The hospital quickly developed a national reputation based on treatments that relied on occupational therapy and a nominal use of drugs.

Sybil Bowers notes:

> *Dr. Carroll remained as the directing physician of the hospital until 1939 when he donated all of the property associated with the hospital to Duke University. This included the nine buildings in Montford, as well as a 400 acre parcel in Beaverdam which was a working farm used for the occupational treatment of patients. He remained as director until 1944, when Duke took over the operations completely. By 1943, the Carroll House became the nurse's home for the hospital. In the 1960s, the building was converted to use as a classroom building for the hospital. Duke owned the property until July 28, 1981, when it sold it to Highland Realty Associates, Ltd.*

After going through several owners, the building is presently used as an office building.

Highland Hospital gained national attention in March 1948 when a fire there caused the death of forty-eight-year-old Zelda Fitzgerald, wife of novelist F. Scott Fitzgerald. Zelda and eight other patients died in the early morning blaze.

6. RUMBOUGH HOUSE

On a grassy knoll overlooking the Montford area sits the majestic queen of Colonial Revival architecture in all her golden splendor. Add a few touches of Queen Anne and Neoclassical elements to dazzle the eye, and the vision is complete.

The full-width wraparound porch extends to the south and west, supported by scroll-bracketed paired columns on quarry-faced stone pedestals. The asymmetrical two-and-a-half-story house has weatherboard siding, the original blue slate hip roof, multiple dormers and five granite chimneys decorated with chimney pots and dentil molding. In a 2002 renovation, the chimneys were dismantled stone by stone, concrete slabs were installed to seal off the fireplaces, the chimneys were reinstalled and the mortar was repaired.

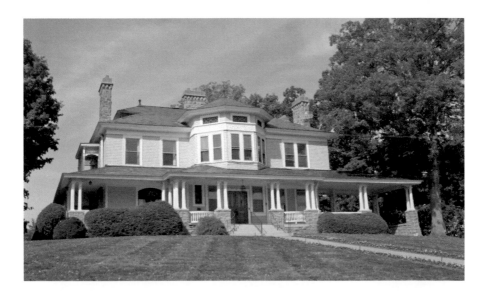

The most prominent feature of the house is the façade's five-sided central bay, with paired windows and a wraparound cornice frieze decorated with floral motifs. The bay continues as an attic story with windows, dentil molding and a pyramidal roof. An unusual feature of the porte-cochere, located to the east, is its one-piece granite capstone, twelve feet long by twenty inches wide by six inches thick, supported by a battered pedestal.

Four fluted columns with fanciful capitals, carved brackets and a multiple-spindle frieze support a small covered second-story balcony to the west. Windows throughout are double-hung with one-over-one lights.

James E. Rumbough came to Asheville in 1880 from Hot Springs, where his father, James H. Rumbough, was owner of the Mountain Park Hotel. The son became the first and only mayor of Montford, from its initial incorporation in 1893 until annexation by the city of Asheville in 1904. Rumbough and his wife, Martha, occupied the house at 49 Zillicoa upon its completion in 1892. She was the daughter of John G. Baker, a wealthy Philadelphia inventor who hired S.S. Gotley of Cincinnati as architect to build a luxurious home for his daughter. Baker supervised construction and material acquisition, eventually deeding the property to Mrs. Rumbough as a gift.

Duke University purchased the property in 1952 as the administration building for Highland Hospital, and in 1981, it was sold to Highland Realty Associates, Ltd. The Rumbough House continued to be used as an administration building for several medical organizations until 2000, when it became vacant.

7. FRANCES APARTMENTS

The fertile imagination of an unknown architect created one of the most fanciful and expressive buildings in the Montford area. Located at 333 Cumberland Avenue, the multistory brick-and-cast-concrete apartment

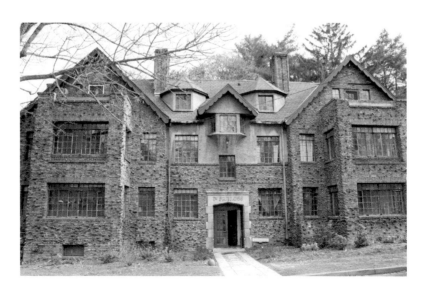

building called the Frances was built on land purchased around 1922 by Benjamin Holder. The building, completed in 1926, was named in honor of Holder's wife, Frances.

The symmetrical façade features two-story rectangular wings set into three-story gabled end bays. A centrally located gabled dormer, unusual in its configuration, sits between twin pyramidal roofed dormers. All of the gables feature large scalloped bargeboards, a tribute to the invention of the scroll saw. Windows are steel casement, with flat arch lintels composed of angled brick soldier courses with a horizontal brick keystone.

The coarse, uneven texture of the brick walls was created by applying an excess of mortar and allowing it to drip down the sides of the brick and harden. By choosing bricks that varied in color and shading and allowing random projections from the wall, the architect created the appearance of a tapestry.

Over the main entrance's angular arch, the apartment's name in bas-relief is placed, utilizing a distinctive Art Nouveau script.

CHESTNUT HILL HISTORIC DISTRICT

INTRODUCTION

The arrival of the railroad in 1880 opened Asheville to the outside world. With its temperate climate, invigorating air and breathtaking mountain vistas, Asheville quickly became one of the most sought-after locations in the Southeast. The opening of Colonel Frank Coxe's luxurious Battery Park Hotel in 1886 attracted many influential visitors seeking relief from severe northern winters and debilitating southern heat.

The discovery of Asheville prompted many visitors to seek permanent residence, as evidenced by the increase in population from 2,610 in 1880 to 18,672 in 1910. To accommodate this rising population, new construction on the northern edge of the city between Merrimon Avenue and Patton Mountain quickly developed into elegant structures mirroring the predominant period styles of Queen Anne, Shingle and Colonial Revival. The area, centered on East Chestnut, North Liberty and Orange Streets, became known as Chestnut Hill.

While the majority of homes were for residential purposes, developers, taking advantage of the proximity to the downtown area, erected high-quality single-family rental dwellings to accommodate the arrival of more than thirty thousand summer visitors. One such far-seeing investor was Dr. J.E. David, who hired Richard Sharp Smith in 1880 to design five rental cottages on the north side of East Chestnut Street between North Liberty and Washington Streets. In 1896, Smith had designed a house at 166 Chestnut Street for Dr. H.S. Lambert—two stories with shingles over pebbledash and

a five-sided bay—thus giving Smith the distinction of having designed all the buildings on the north side of the block. David had purchased the property from George Willis Pack with the deed stipulating that a fifty-foot setback be maintained for all new construction, and David further enhanced the attractiveness of the street with plantings of sycamore trees.

As the neighborhood expanded into the late 1920s, the elegant building styles were replaced by a more modest style favored by the lawyers, teachers and entrepreneurs moving into the area, thus giving the district a more diverse architectural mix.

East Chestnut Street, long considered a showcase of Victorian architecture, suffered from the construction of five apartment buildings in the 1920s, several modern commercial establishments in the 1970s and a large chain restaurant in the 1980s. Fortunately, many of the remaining historic structures have been rehabilitated for professional offices, bed-and-breakfasts and apartments while retaining the historic integrity of the original designs.

In 1983, the National Register of Historic Places designated the area, with its more than two hundred buildings, as the Chestnut Hill Historic District.

Of historical and social significance is the nearby childhood home of Dr. Mary Frances Shuford at 50 Orange Street. Built in 1880, the two-story Queen Anne–style house is multi-gabled, with a projecting bay. Detailing includes scroll brackets, a fish-scale slate roof and a gable window flanked by sunburst detailing. Catholic Social Services now occupies the building.

Shuford was instrumental in providing leadership to supply adequate hospital facilities and medical insurance for Asheville's African American population. In 1941, she opened a 12-bed clinic at 269 College Street for

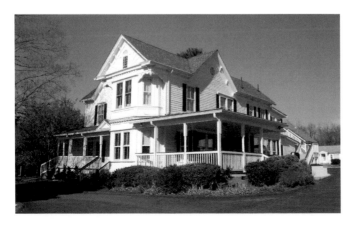

The former home of Dr. Mary Frances Shuford now houses Catholic Social Services.

their exclusive use. The clinic was reorganized in 1942 as the Asheville Colored Hospital. Larger quarters were obtained in 1943 with the move to a thirty-five-patient facility at the northwest corner of Biltmore Avenue and Southside Street. In 1951, the Asheville Colored Hospital, having merged with Memorial Mission Hospital, transferred its patients to Victoria Hospital. Victoria Hospital's 120-bed facility had merged in 1950 with Memorial Mission, which included the thirty-two acres that now comprise the Memorial Mission Hospital campus.

To provide medical coverage for her patients, Shuford created a form of health insurance administered by the creation of the Health Security Company. To cover the cost of treatment, each participant paid a weekly premium of twenty-five cents. Shuford continued a small practice at her Orange Street home into her eighties. She died in 1983 at the age of eighty-six.

The Asheville Colored Hospital building was sold in 1951 to Jesse Ray Sr. for use as a funeral home. The building now serves as legal offices.

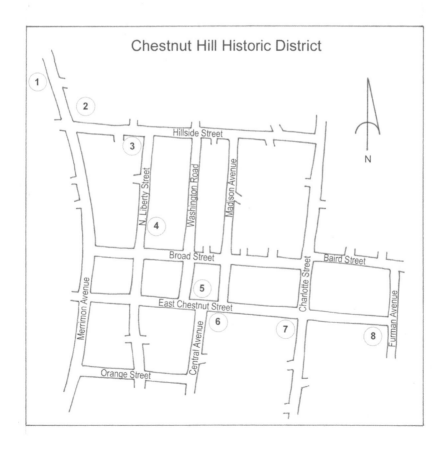

1. ASHEVILLE FIRE STATION— HARLEY SHUFORD BUILDING

The Harley Shuford Building, originally known as Fire Station Number 4, is located at 300 Merrimon Avenue. The building, designed by Douglas Ellington, was built in 1927 to provide municipal services to Asheville's fast-growing northern population.

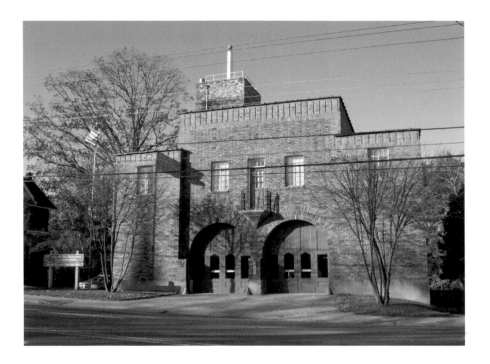

The two-story rectilinear, three-part composition features a front façade of multi-paneled Roman arched twin garage doors with arches laid in multiple courses of soldier brick. A second-story wrought-iron balcony, supported by a tapered concrete base, sits in front of a multi-light paneled door under a four-pane transom. Ellington's distinctive feather motif sits above the lintel. The balcony is flanked by casement windows set in pairs under a multi-light transom. The highly decorative cornice features a base of soldier bricks under ornamental bands of masonry with stack bond columns that alternate with recessed soldier courses. A five-story tower used for hose drying and training purposes sits to the rear.

Ellington's genius as a watercolorist is evident in his choice of multicolored bricks set in a masonry pattern called in-and-out—headers and stretchers alternating vertically. The effect is most pronounced when the rays of the morning sun illuminate the front façade, producing the effect of a shimmering and glowing tapestry rug.

Fire Station Number 4 served the community until the 1970s, when it was taken out of commission. It now serves as the administrative unit for the Arson Task Force. The building was named in honor of Captain Harley Shuford for his vision in creating the task force.

2. CLAXTON SCHOOL

A fitting tribute to the Greek value of academic achievement is Claxton Elementary School, built from 1922 to 1924 at the intersection of Merrimon Avenue and Hillside Street. Architect Ronald Greene's vision of the Neoclassical style has stood the test of time and is as moving and endearing today as when constructed.

The three-story structure, reminiscent of a modern-day flying wing poised for flight, extends outward from a central hub, within which the architect has placed engaged fluted columns, flanked by tripartite windows and topped with Doric capitals. The three main entrances, inset and centered within the central hub, contain glass-paneled metal doors and sidelights placed beneath a one-light transom. The door surrounds are tapered at the bottom

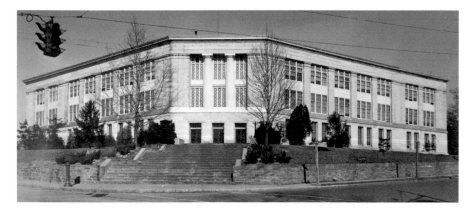

Claxton School. *Courtesy of the North Carolina Collection, Pack Memorial Public Library, Asheville, North Carolina.*

(battered) and contain circular disks called bezants. The ashlar façade is composed of hollow clay tiles faced with a cast concrete veneer. In 1925, to alleviate overcrowded conditions, two bays were added to each wing, thus adding twelve new classrooms to the school.

The decade of the 1920s saw Asheville's population increase from 28,500 in 1920 to over 50,000 in 1930, placing an increasing burden on Asheville's educational system to maintain adequate classroom space. To alleviate this problem, bond issues were passed to provide for construction of eight new schools: Claxton, to provide for the northern section; Stephens-Lee for the African American community; Vance, Aycock, Hall Fletcher and Eugene Rankin for West Asheville residents; Newton for southern portions of the city; and Asheville Senior High School on McDowell Street.

The school was named for Philander Priestly Claxton, Asheville City School's first superintendent, who served from 1887 until 1893. Claxton, a native of Tennessee, graduated from the University of Tennessee and attended Johns Hopkins University. He was appointed United States commissioner of education in 1911, where he served under Presidents Taft and Wilson until 1921. He continued his educational career with stints in Alabama and Texas, finally ending his career as president of Austin Peay Normal School in Clarksville, Tennessee, where he retired in 1946. He died in 1957 at the age of ninety-four.

3. VICTORIAN HOUSE

This beautiful 1890s Victorian residence, located at 76 North Liberty Street, is a combination of Second Empire and Queen Anne styling. It is two stories tall, with a three-story square tower topped by a mansard roof of slate shingles. The house features Queen Anne–style shingle siding applied in the form of fish scales (called imbrecation) on the tower roof, the third story of the tower and the two projecting gables. Weatherboard siding covers the remainder of the house. The prominent center gable contains a bracketed overhang, flared eaves and a saw-tooth frieze positioned over clipped corners.

The upper-story windows feature one-over-one lights. The metal roof has standing seam joints, which are formed by turning up the edges of adjacent sheets and then folding them over to create a waterproof joint.

The main entrance, positioned at the base of the tower, features a double-leaf door with overhead transom. The highly decorated one-story porch

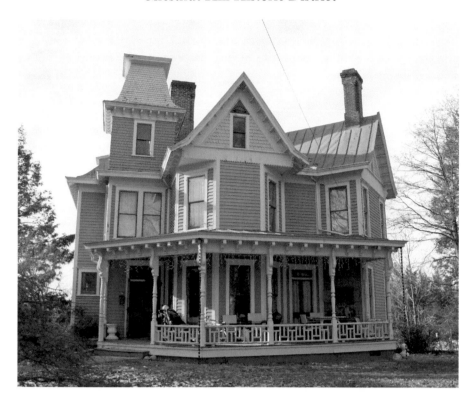

consists of a curvilinear bracketed cornice, turned posts and a Chinese-Chippendale balustrade.

Because the architect is unknown, it is possible that the builder constructed the house based on his own plans. This was common during the late 1900s, since architects were only starting to establish themselves as professionals.

4. BEAUFORT HOUSE INN

On a slight rise, at the end of a gently curving driveway, sits an eloquent testimony to the Victorian lifestyle of afternoon teas, Sunday buggy rides and the quiet splendor of small-town life.

A highly ornamented Queen Anne–style house, Beaufort Lodge was built at 61 North Liberty Street for Theodore F. Davidson, North Carolina attorney general from 1885 to 1893. A Civil War veteran, state Democratic Party leader and highly successful lawyer, Davidson was elected mayor of Asheville in 1895. He was unsuccessful in his bid for governor in 1904. The house was designed by architect A.L. Melton and completed in 1895.

Decorative intersecting gables generate an overall impression of exuberance and luxury, making this the most fanciful house in the neighborhood. The full-width veranda connects a bracketed pergola at the southern end to the porte-cochere at the northern end. Tapered Tuscan columns on paneled pedestals and a decorative balustrade enhance the veranda.

A two-story bowed bay projects from the second-story center, creating clipped corners for the massive gable overhead. Curved brackets support the elaborately carved denticulated cornice that carries around the front. Hip-roofed dormers flank the second-story bay. Major windows are double-hung with one-over-one lights.

A mix of siding materials, typical in the Queen Anne style, is accomplished by using weatherboard on the first floor, shingles on the second and a mixture of decorative shingles with fanlights in the third-story gable.

Upon Davidson's death in 1931, at the age of eighty-six, the house passed through several generations of family members before being sold in 1947. One notable boarder during 1947 was actor Charlton Heston, then director of the Asheville Community Theater, who lived in the house with his wife, Lydia.

The house continued as a residence until 1964, when it was sold and renovated into separate apartments, but owing to time and neglect, the house deteriorated to the point where it was in danger of being replaced with a

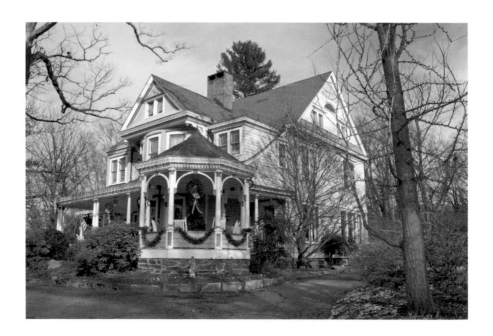

parking lot. Dr. and Mrs. Lon McAnally purchased the property in 1977 and began a refurbishing project that returned the house to its Victorian elegance. In 1993, the house was purchased as a single-family residence, subsequently converted into a bed-and-breakfast and then renamed Beaufort House.

5. CHESTNUT STREET INN BED & BREAKFAST

The Chestnut Street Inn, located at 176 East Chestnut Street, was built circa 1905 and is an excellent example of the Colonial Revival style prominent from 1870 to the 1920s and beyond. The two-story brick structure has a full-width porch supported by sturdy Tuscan columns and decorative balustrades.

The main entrance features a glass-paneled door with oversize side lights surmounted by a geometrically detailed fanlight. The second-story central bay contains a three-part window display crowned by panels containing decorative festoons or swags. The bay is flanked by double-hung windows with brick quoining surrounds and one-over-one lights. A Palladian window rests within a central pedimented dormer containing flared eaves and a cornice return. A cornice containing paired modillion blocks carries around the perimeter of the shingled hip roof. The Washington Road façade features a one-story semicircular portico supported by Tuscan columns.

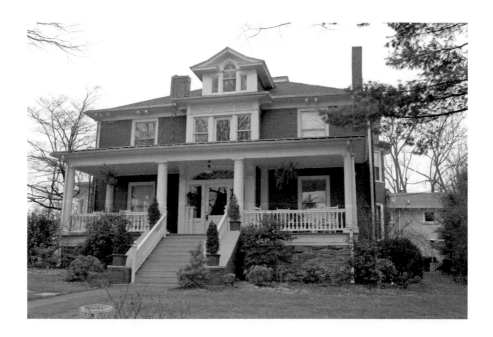

In 1883, William R. Whitson purchased property on the corner of Chestnut Street and Washington Road from George Pack and constructed a frame house. Eventually finding it unsuitable, and desiring to build a larger structure, he moved the existing house farther up Washington Road—where it still exists at No. 19— and proceeded to construct his grand vision in the Colonial Revival style.

6. ANNIE WEST HOUSE

The Annie West House is a one-and-a-half-story cottage-style residence designed by Asheville architect Richard Sharp Smith and built in 1900. Typical of Smith's designs in the cottage style, the building features half-timbering and pebbledash wall finishes. The house, located at 189 East Chestnut Street, features a prominent center gable, flared eaves and flanking dormers. The full-width porch contains Montford posts over closely spaced square balusters.

The centrally located first-story bay features two sets of ribbon windows, requiring the main entrance to be placed to the side. A polygonal bay window extends to the east. Paired upper-level windows contain diamond panes with lintels slightly angled at the top. A flared side gable extends to form the veranda roof.

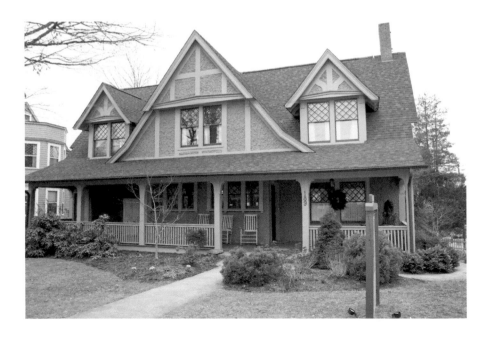

7. JETER PRITCHARD HOUSE

This strikingly handsome, multi-gabled Queen Anne frame house, located at 223 East Chestnut Street, was originally built in 1895 by architect James A. Tennent as his private residence. It was sold in 1904 to former U.S. senator Jeter Conley Pritchard.

The two-story house has projecting gables, a standing seam metal roof, one-over-one window lights and weatherboard siding. The outstanding features of the house are its full-width porch that wraps around to the east, with turned posts that support a highly ornate frieze atop oversized scroll brackets, and a two-tiered balustrade with running arches above and turned spindles below.

Pritchard, a lifelong Republican, was elected to fill the vacancy in Congress left by the death of Zebulon Vance in 1894. Pritchard was reelected and remained in the Senate until 1901. In 1903, he was appointed by President Theodore Roosevelt as an associate justice of the Supreme Court for the District of Columbia. In 1904, he was named judge of the Appeals Court for the Fourth District, a post he held until his death in 1921 at the age of sixty-four. He is buried in Riverside Cemetery, and Pritchard Park in downtown Asheville is named in his honor.

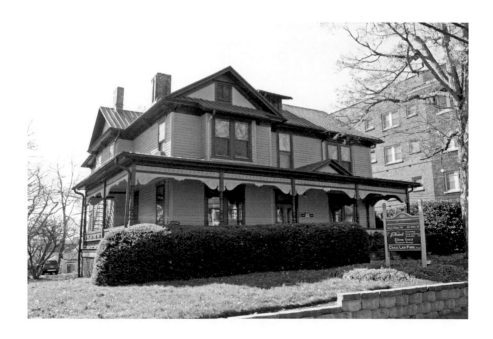

Asheville architect James A. Tennent was also responsible for the design of the 1876 Asheville Courthouse, a mansard-roofed structure; the 1892 City Hall that framed the east end of Pack Square; and numerous other commercial, religious and residential buildings.

8. PRINCESS ANNE HOTEL

The three-story, Shingle-style Princess Anne Hotel, built in the 1920s at 301 Chestnut Street, was initially owned by Anne O'Connell, a local health provider whose demeanor and flowing red hair earned her the name Princess Anne, thus providing a title for the hotel. George Mercer, the father of Johnny Mercer—famous songwriter of the 1930s, '40s and '50s—was once owner of the Princess Anne.

The recessed main entrance, angled to face Chestnut and Furman Streets, features a porte-cochere surmounted by a polygonal bay of double-hung, two-over-one-light windows. The entrance doors are double-leaf, with sidelights and a multiple-light transom. Corinthian columns greet the visitor at the lobby entrance.

Asheville preservationist Howard Stafford thoroughly renovated the structure when he bought it in 2003, updating the original plumbing and

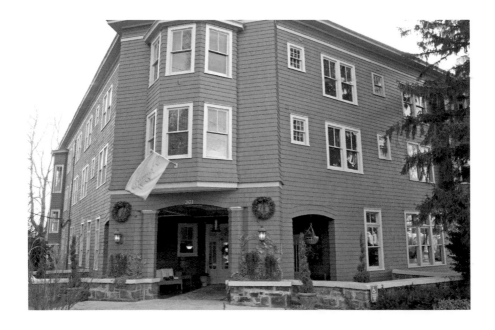

electrical wiring and creating sixteen fashionable suites—complete with high-speed Internet, micro-kitchens and flat-panel televisions. Although the hotel is now complete with modern amenities, Stafford has managed to retain the original charm and warmth of the original hotel.

The hotel has had a rich and varied past. In 1945, the United States Navy occupied Appalachian Hall in Kenilworth, which necessitated the temporary transfer of patients from there to the Princess Anne. In 1994, the hotel, then being used as a retirement facility, was purchased by the Maharishi Vedic Education Corporation for short-term rental, an educational facility and a spa.

The building is listed on the National Register of Historic Places.

MANOR INN AND ALBEMARLE PARK

In 1886, William Greene Raoul purchased a forty-two-acre farm on Charlotte Street for the express purpose of creating a summer residence for his wife and seven children. However, because he was unable to return the following year due to pressing business interests—he was president of the Mexican National Railroad—the farm lay idle and unused. Concern for the health of his son Thomas—diagnosed with tuberculosis the previous year—and the desire to regain his investment by dividing the farm into lots for sale prompted Raoul's return to Asheville in 1897.

A boardinghouse was thought to be the quickest way to increase the land value, so in collaboration with New York architect Bradford Gilbert and landscape architect Samuel Parsons Jr., plans were laid for the beginning of what was to become Albemarle Park.

Construction of the first building, the Tudoresque Shingle-style Lodge (or Gatehouse), was begun in early 1898 and featured a majestic tower with conical cap, pebbledash stucco, half-timbering and a granite foundation. The next structure to be built, the Manor, provided twenty-five guest rooms on two floors, with staff housing available on the third. Construction was in the Tudor style, with granite foundation, half-timbering, pebbledash stucco and shingles. The asymmetrical, multi-gabled layout featured three distinctly different shapes—saltbox, triangular and Dutch Gambrel—creating the picturesque look of an "English Inn in America." Construction of two adjacent cottages—the Clover and Columbus—was also started at this time.

The Manor, which featured steam heat, electricity and open fireplaces, was opened for business on January 1, 1898. A three-story wing extending

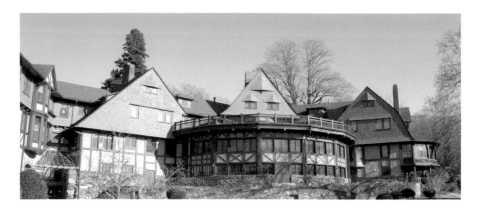

west toward Charlotte Street was added in 1903; it included additional guest rooms, a two-story ballroom and a massive chimney. The need for additional guest rooms and expanded dining facilities prompted further expansion, and a three-story east wing was built in 1916.

E.W. Grove, patent medicine developer and builder of the Grove Park Inn, purchased the property in 1920. Beginning in 1944, the Manor passed through several owners until finally closing in 1984. The Preservation Society subsequently purchased the Manor, Clover and Columbus cottages and the greensward along Cherokee Road. In 1991, new owners purchased the property, eventually converting the Manor into thirty-five apartments.

In the 1950s, Hollywood star Grace Kelley made the Manor her home during the filming of *The Swan* at the Biltmore Estate, and in 1991, the Manor was used in making the movie *The Last of the Mohicans*.

The Manor and cottages were placed on the National Register of Historic Places in 1978.

PROXIMITY PARK AND GROVE PARK
HISTORIC DISTRICTS

ALBEMARLE INN

An enduring tribute to the antebellum southern way of life is the majestic Albemarle Inn, built in 1909 for Dr. and Mrs. Carl V. Reynolds. The two-story Neoclassical building is located at the end of Edgemont Road in the Proximity Park Historic District.

Towering over the front façade is a two-story portico of paired Corinthian fluted columns under a full entablature of panels, modillion blocks and dentil molding. The entablature continues around to form the cornice for the remainder of the house. The main entrance, framed by engaged Corinthian columns, is entered through a segmental arch and features double-leaf paneled doors under a fanlight. Flanked by double-pane sidelights, the entire composition reflects a Palladian motif.

Sited on a random coursed stone foundation, the eleven-room house with weatherboard siding is painted in the traditional white used for Neoclassical buildings. Elaborate first-floor windows flanking the main entrance include pilasters, diamond-pane sidelights and molded cornices. Other windows throughout the house have one-over-one lights. Intricate paneled pilasters topped with Corinthian capitals grace the building corners.

The Reynoldses sold the house in 1920 to a private school, where it operated until being sold in 1929. The house was then converted into a rooming house and named the Albemarle Inn. Its most famous guest was Hungarian composer Belá Bartok (1881–1945), who in 1943 composed his *Third Concerto for Piano*, also known as the *Asheville Concerto*, at the inn.

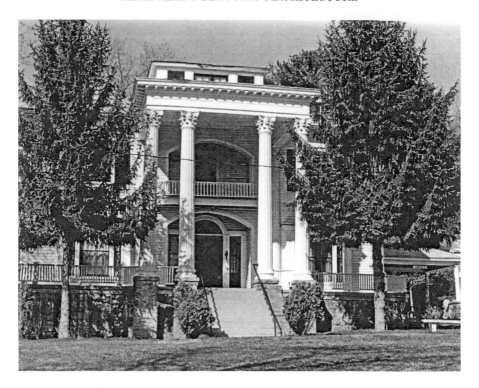

Albemarle Inn. *Courtesy of the North Carolina Collection, Pack Memorial Public Library, Asheville, North Carolina.*

The house passed through several owners until 1980, when it was converted from a rooming house into a bed-and-breakfast. It remains today as one of the more prestigious accommodations in Asheville. The building was placed on the National Register of Historic Places in 1982.

In 1895, Dr. Reynolds returned to his hometown to establish a private practice specializing in tuberculosis. He served as city health officer from 1903 to 1910 and from 1914 to 1923. Dr. Reynolds worked closely with city of Asheville bacteriologist Dr. Lewis McCormick to establish standards for control of water, milk and bread and for promoting the vaccinations of schoolchildren. In 1905, Dr. McCormick initiated a campaign to reduce disease from the common housefly. Called "Swat the Fly," the program was highly effective in reducing the spread of typhoid fever. McCormick Field—home of the Asheville Tourists professional baseball club—was named in his honor.

Reynolds was state health officer from 1934 to 1948 and was elected president of the State Board of Health in 1933. As a prominent advocate for public health, he was a driving force in the establishment of the School

of Public Health at the University of North Carolina–Chapel Hill, where he served on the faculty in 1935. Reynolds died in 1963 at the age of ninety and is buried in Riverside Cemetery.

In 1907, Dr. Reynolds, with a group of prominent Asheville investors, formed the Proximity Park Corporation to purchase 131 acres at the northern end of Charlotte Street below Sunset Mountain. The property, including a nine-hole golf course, was purchased from the estate of George Pack for the purpose of developing middle- and upper-middle-class homesites. Initially, eighty-eight sites were laid within a 30-acre area. By 1925, approximately fifty-eight homes had been constructed with a mix of architectural styles, the most prominent being Craftsman, followed by Colonial Revival.

In 2008, the Proximity Park Historic District was listed in the National Register of Historic Places.

St. Mary's Episcopal Church

The cornerstone of St. Mary's Episcopal Church was laid in 1914 at the corner of Macon Avenue and Charlotte Street. The first service was held in the new building on Christmas Day of the same year. Richard Sharp Smith, a vestryman of the new parish, designed the church in the Gothic Revival style reminiscent of his native England. The one-story brick building is of cruciform plan, with a quarry-faced stone foundation. The main entrance facing Macon Avenue has a pointed-arch stone entrance with double oak doors topped by an arched window of three lights. The triple windows are lancet-arched cut stone outlined by quoins and having continuous sills.

Smith designed an adjoining rectory in the English cottage style, but it was not built until 1925, a year after his death. The rectory is one-and-a-half stories tall, with walls of brick and stucco. The roof is in the jerkinhead, or clipped gable, style—a combination of a gable roof and a hipped roof.

The church's gable elevation, which faces Charlotte Street, contains three lancet windows joined together by quoins of cut stone. Statues of Joseph and Jesus on the left and Mary on the right are enclosed in brick niches and protected by pedimented hoods of cut stone. At the apex of the gable, a bell is housed in a corbelled canopy of cut stone; it is rung at the beginning of Mass each Sunday and during the Angelus at the end of the service. A series of small buttresses is located on the north elevation. In 1960, a church

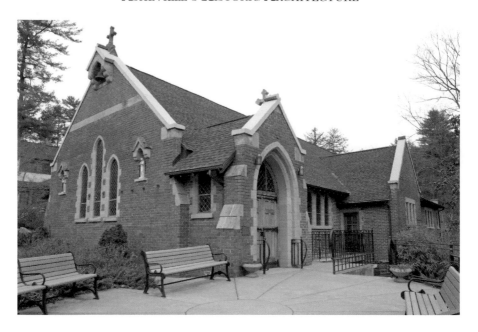

expansion extended the east elevation by twenty-two feet, and the organ was moved from the main floor to the newly installed choir loft.

The original landscaping plan was created by Chauncey Beadle of the Biltmore Estate. Beadle came to Asheville in 1890 to work for Frederick Law Olmsted, and his career progressed from being the chief nurseryman to the superintendent and treasurer of the Biltmore Estate. He is best known for his work with azaleas, becoming the leading authority on native azaleas in the United States. Beadle lived on the estate until his death in 1950. In addition to his landscaping work at St. Mary's, Beadle worked with E.W. Grove to develop a master plan for the landscaping of the Grove Park neighborhood.

In the 1960s, landscaping for the church was further enhanced by landscape architect Doan Ogden, who came to Asheville from Michigan in 1931 to teach at Warren Wilson College, then known as Asheville Farm School. Eventually building a house designed by Tony Lord in the Kenilworth neighborhood, Ogden and his wife developed nine acres of gardens known as Kenilworth Gardens, which are opened to the public every Father's Day. During his career, Ogden completed approximately two thousand landscape designs for varying clients; his best-known work is the Botanical Gardens near the University of North Carolina at Asheville. Ogden died in 1989 at the age of eighty-one. In 2011, the church expanded to include classrooms and a parish hall.

The building was placed on the National Register of Historic Places in 1994.

E. W. Grove Office Building

This one-story Craftsman-style bungalow located at 324 Charlotte Street was built in 1909 as the sales office for E.W. Grove's six-hundred-acre residential development program. The building was designed by the architectural firm of Smith and Carrier and is constructed of uncoursed granite masonry with beaded mortar joints. The front façade features a window band of five casement windows set within a wooden framework, while the north and west walls contain ribbon windows surmounted by decorative transom bars. Casement windows with decorative Arts and Crafts inserts are used throughout. Wide overhangs with exposed rafters are set under a Mission-style gable roof. The main entrance, through a recessed porch supported by ashlar columns, features a stone lintel with a dominant keystone.

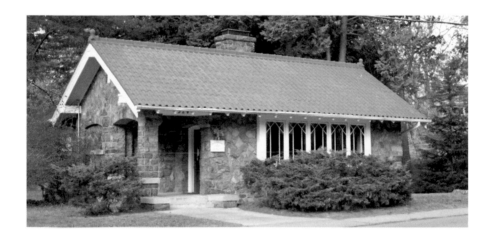

After Grove's death in 1927, the building remained vacant until 1949, when Grove's estate transferred it and the adjacent park to the City of Asheville. The Asheville Art Museum occupied the building until 1966, when it relocated to the Northwestern Bank Building in 1996 and then, in 1992, to its present location as part of Pack Place. The building's next occupant was the *Arts Journal*, which began publishing in 1976 and continued until 1992. The building remained vacant until 2008, when the City of Asheville signed a ten-year lease with the Preservation Society of Asheville and Buncombe County for office use. Renovation began in 2009 with the replacement of the Mission-style roof, along with extensive interior refurbishing.

Advertisement for Grove's Tasteless Chill Tonic.
Courtesy of the Grove Park Inn.

Health concerns motivated Grove's relocation to Asheville in the late 1890s from St. Louis, where he had established the Paris Medicine Company, a firm manufacturing a patent medicine product under the name of Grove's Tasteless Chill Tonic. Grove's revolutionary idea was to combine sugar, honey and iron with quinine to create a palatable product to alleviate the effects of malaria, which affected a large number of the southern population. Once in Asheville, Grove began purchasing large tracts of land at the northern end of Charlotte Street for the purpose of developing a residential neighborhood of middle- and upper-middle-class clients. Major construction began in 1908 and continued into 1914. The most prominent architectural styles within the Grove Park area are Colonial Revival, Tudor Revival, Bungalow and American Four Square.

Chauncey Beadle, head nurseryman of the Biltmore Estate, was given the task of designing the landscape plan for Grove Park. Using theories espoused by his mentor, Frederick Law Olmsted, Beadle laid out curvilinear streets and added large numbers of trees, stone retaining walls and numerous sidewalks.

Many of the streets in Grove Park were named for Grove's friends and relatives, including Evelyn Place for his daughter and Gertrude Place for his second wife.

THE GROVE PARK INN

The Grove Park Inn (GPI), located on the western slope of Sunset Mountain, was completed in 1913 as an enduring tribute to the driving force of two men: Edwin Wiley Grove, a far-reaching real estate developer and patent

medicine manufacturer, for his vision and financial guidance; and Grove's son-in-law, Fred Seely, for his artistic inn design and exceptional skill in organizing and supervising completion of the hotel.

With the coming of the railroad to Asheville in 1880 and the construction of the prestigious Battery Park Hotel in 1886, the city was becoming a fashionable year-round resort for the rich and famous. Grove, seeking to take advantage of the influx of "summer people"—an estimated fifty thousand in 1900—envisioned a multistory luxury hotel that would cater to a prosperous clientele. At the north end of Charlotte Street, Grove

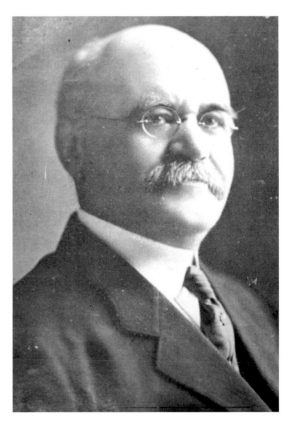

Edwin Wiley Grove. *Courtesy of the North Carolina Collection, Pack Memorial Public Library, Asheville, North Carolina.*

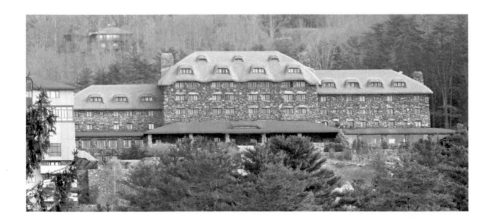

had amassed over six hundred acres, including portions of Sunset Mountain, where he planned to place his hotel.

Grove visualized a structure in the mode of the rustic Grand Canyon Hotel in Yellowstone National Park. Dissatisfied with numerous submissions from leading architects, he finally accepted a design sketch from Seely.

The concept was for a six-story, 150-room hotel that would utilize wooden timbers and uncut granite boulders collected from the local mountains. The granite walls, supported by a reinforced concrete frame, would be capped with a roof of red clay tiles pierced by a series of curvilinear dormers. Oversized granite lintels would support paired wooden casement windows used throughout the inn. With only minor modifications, Seely's sketch would become a reality.

The grand opening, on July 12, 1913, was presided over by Seely, who introduced William Jennings Bryan, secretary of state under President Woodrow Wilson. Bryan's speech to an all-male throng of four hundred distinguished guests contains this memorable passage: "Today we stand in this wonderful hotel, not built for a few, but for the multitudes that will come and go. I congratulate these men. They have built for the ages."

In 1914, Seely assumed managerial control of the Grove Park Inn and signed a lease agreement with Grove that would terminate on January 1, 1928. Seeking to diversify his business interests, Seely, in 1917, purchased Biltmore Estate Industries—producers of furniture, woodcarvings and homespun cloth—from Edith Vanderbilt, widow of George Vanderbilt, who had died in 1914. The existing workshops in Biltmore Village were moved to three newly constructed buildings adjacent to the Grove Park Inn and renamed Biltmore Industries.

A breach in their relationship caused Seely to file a lawsuit against Grove in 1925 seeking the right to retain control of the Grove Park Inn after Grove's death. Learning that he would not be retained after the expiration of his lease, Seely constructed three additional Biltmore Industries buildings, thus assuring himself a continued source of income.

After Grove's death in 1927, the inn was sold—in violation of Grove's will—to outside interests, who eventually defaulted on the mortgage. Under the new owners, however, the inn continued its successful tradition, which had been established by Seely, and attracted numerous high-profile guests.

When America entered World War II, it was necessary to intern foreign diplomats living in the United States until travel plans were formulated for their return to a neutral country. From April to June 1942, several hundred foreign diplomats were housed at the Grove Park Inn. Close upon their departure, the

United States Navy utilized the facility for the rest and rehabilitation of navy aviators and wounded seamen. In October 1943, the United States Army redistribution center for returning combat soldiers was established at the George Vanderbilt Hotel (now the Vanderbilt Apartments), the Asheville-Biltmore Hotel (now the Altamont Apartments), the Battery Park Hotel and finally the Grove Park Inn.

In February 1942, Philippine president Manuel Quezon and his family were forced to flee from the invading Japanese by submarine to Australia and finally to the United States. From April to June 1944, in a small stone cottage adjacent to the Grove Park Inn called the Anne Hathaway Cottage, Quezon, with his wife and staff, established the presidency of the Philippines.

Fred Seely. *Courtesy of the North Carolina Collection, Pack Memorial Public Library, Asheville, North Carolina.*

A postwar return to normalcy saw a gradual decline in business due in part to poor promotion and failure to make much-needed improvements. A dramatic change in fortunes came about in 1955 with the purchase of the Grove Park Inn by Charles Sammons, a self-made insurance millionaire and the president of the Jack Tar Corporation. Under the guidance of Sammons, the inn underwent a number of major additions and renovations, including a golf course in 1976, renovation of the clubhouse in 1985, creation of a new sports center in 1985, the erection of the 202-room Sammons Wing in 1984, the 166-room Vanderbilt Wing in 1988 and finally a $44 million forty-thousand-square-foot health spa in 2001.

Following Charles Sammons's death in 1988, his wife, Elaine, became chairwoman of the Board of Sammons Enterprises, where she continued to carry on their visionary approach to establishing and maintaining the Grove Park Inn until her death in 2009 at the age of ninety-one.

The Grove Park Inn remains one of the finest hotels in America, truly one "built for the ages." The Grove Park Inn was placed on the National Register of Historic Places in 1973.

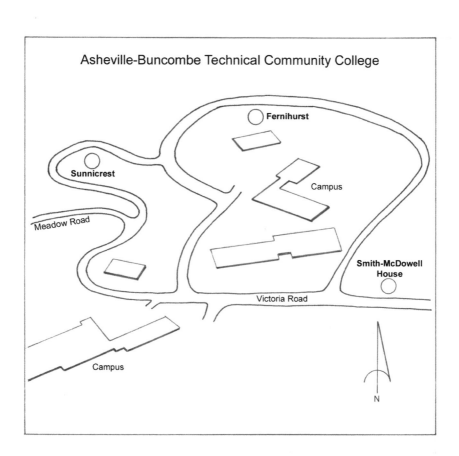

Asheville-Buncombe Technical Community College

Fernihurst

Sunnicrest

Campus

Meadow Road

Smith-McDowell House

Victoria Road

Campus

N

Asheville-Buncombe Technical Community College Area

Smith-McDowell House

Believed to be the oldest surviving structure in Asheville and the oldest brick structure in Buncombe County, the Smith-McDowell House is a two-story double-pile (two rooms deep) plan with a center hall that provides privacy for side rooms and creates a passageway for cool air to flow through the house during hot, humid times of the year. A brick structure of this size and type, with walls twelve to twenty inches thick, was unusual for this area and could only be built by someone with a great deal of wealth. James McConnell Smith was such a man. Smith's wealth came from large landholdings, a ferry across the French Broad River, mercantile interests, a tannery and a gold mine in Georgia. He was also the owner of the Buck Hotel on North Main Street (now Broadway), on a site now occupied by a parking garage.

Smith had the house built in 1840 for his son, John Patton Smith. John died suddenly in 1857 at the age of thirty-four, however, and never having married and with no heirs, he died intestate, requiring the house to be sold at public auction. The buyer was James Smith's son-in-law, William McDowell, who lived in the house with his wife and twelve children until 1881. Since then, subsequent owners have made modifications to the house, the most notable being a sunroom built in the late 1890s and a Greek entrance porch with Ionic columns added around 1915 by Richard Sharp Smith. The firm of Frederick Law Olmsted provided the landscaping design around 1900.

The Flemish bond brick house is five bays wide, with a two-tiered porch that is an extension of the gable roof and features six fluted columns on

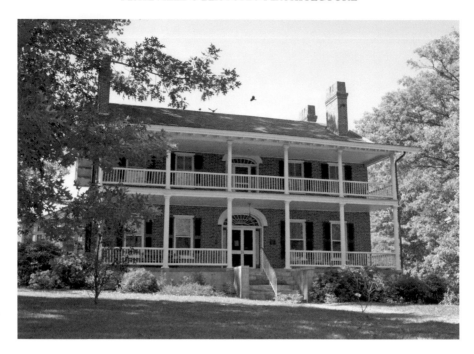

each level. The double-door main entrance, indicative of the Federal style, prominent from 1780 to 1820, has vertical sidelights and a fanlight centered over the door.

Since 1976, the Western North Carolina Historical Association, under the direction of Asheville architect Henry Gaines, has worked diligently to restore the Smith-McDowell House, which now operates as a nonprofit museum currently open to the public. The Smith-McDowell House was placed on the National Register of Historic Places in 1975.

FERNIHURST

In 1875, on a hill overlooking the French Broad and Swannanoa Rivers, Colonel John Kerr Connally constructed an imposing two-story brick Italianate villa that he named Fernihurst after the family's ancestral castle in Scotland. The building is three bays wide with a pedimented central pavilion that sits over a blind lunette. The lunette is composed of a keystone and sunburst appliqué framed by Tuscan pilasters. The extensive cornice contains sturdy brackets interspersed with dentil moldings. The first-floor windows are flat arched, while the second, indicative of the Italianate style, are mainly round arched with decorative tracery highlights in the upper sections.

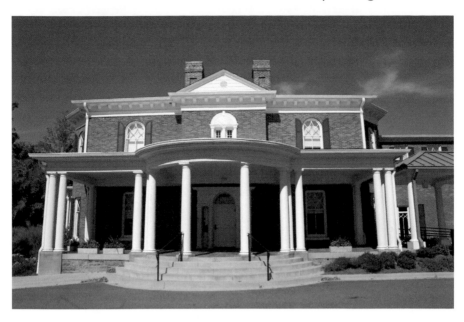

The main entrance entablature, pierced by a fanlight, includes sidelights, flanking pilasters and free-standing Tuscan columns. The front façade features a full-width, one-story porch, supported with paired Tuscan columns and a semicircular portico extending from the center.

After Colonel Connally's death in 1904 and his wife Alice's in 1917, their daughter Mary lived in the house until 1929. The house remained empty until John Curran purchased the property in 1933, changing the name of the property to Viewmont. He quickly proceeded to institute an extensive remodeling program with Asheville architect Henry I. Gaines. The property passed through several owners until 1961, when the Catholic Diocese of North Carolina obtained the facility for a retreat and conference center. It was then named Mount Mary. In 1974, the property, along with the Smith-McDowell House and seventy-nine acres, was sold to the Asheville-Buncombe Technical Community College. In 2008, after a $2.9 million remodeling project, the house was ready for use by the Culinary Arts program as an instructional facility that allows students to experience the preparation and service of fine food to the general public.

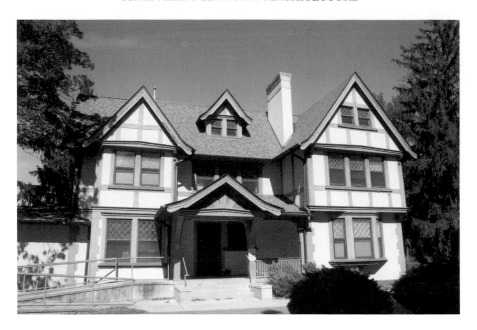

SUNNICREST

Between 1895 and 1900, George Vanderbilt directed Richard Sharp Smith, supervising architect of the Biltmore Estate, to construct six rental villas on Vernon Hill, a picturesque plateau overlooking the French Broad and Swannanoa Rivers. Each villa was two to two and a half stories tall, rough cast (pebbledash) finish, steam heated, with adjacent coach house and servants' quarters. Each house was completely furnished, except for silver, linens and blankets, with rents ranging from $200 to $350 per month. In addition to carrying distinctive names such as Spurwood, Hillcote, Washington Cottage, Ridgelawn, Westdale and Sunnicrest, each structure was designed in a distinctive architectural style, emphasizing the versatility of Smith's creativeness.

Of the six, only Sunnicrest remains today as a reminder of the group of villas that once dominated this picturesque hillside. Sunnicrest is two and a half stories tall and has applied half-timbering, flared eaves, first-floor pebbledash and brick quoining.

Sunnicrest was sold in 1911 as a private residence to C.W. Radeker. It remained in the family until 1990, when it became the property of Asheville-Buncombe Technical Community College. In 1997, the building was restored for use as the Business and Industry Services.

Kenilworth–Biltmore Village Area

St. Matthias' Episcopal Church

Built for the oldest congregation of black Episcopalians in Western North Carolina, St. Matthias is a small Gothic church located off Charlotte Street on a hill across from the Asheville Public Works Building. In 1865, a congregation of newly freed slaves began meeting in a two-story frame building under the direction of Jarvis Buxton. The church was known as Trinity Chapel. Continued growth of the congregation necessitated the construction of a larger building, and Bishop Joseph Blount Cheshire laid the cornerstone for the new structure in 1894. Following completion in 1896, the church was renamed St. Matthias.

The one-story gabled brick church, which seats two hundred, is designed in a cruciform plan on an east–west axis. The main entrance, facing Charlotte Street on the west, features a double-leaf oak-paneled door under a paneled arch with a Gothic-shaped surround of stone vouissers. Above the door, the stained-glass rose window incorporates tracery in a cinquefoil (five-lobed) pattern, and at the gable, a hood molded pointed-arch wooden ventilator completes the vertical alignment. The deep-set lancet windows used throughout the building have stone sills and brick hoodmolds typical of the artistry of brick mason James Vester Miller. A small chapel is appended to the southeast corner of the church.

Stepped buttresses with stone caps are used throughout to contain the horizontal thrust of the vertical walls. The brickwork pattern is in the American (common bond) style, with particular emphasis on the darkening

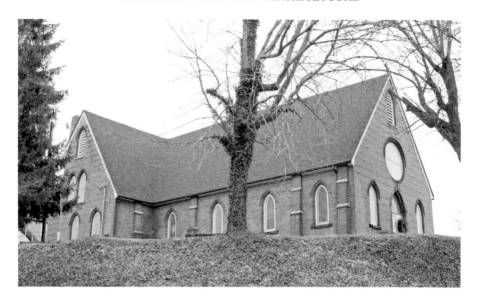

of the header courses that creates a distinctly horizontal striping. The apse, housing the altar, is a semi-polygonal projection to the east and contains double lancet windows.

Typical of a country church at the close of the nineteenth century, this small church evokes a time and place when life was simpler and provides a place for quiet reflection.

The building was placed on the National Register of Historic Places in 1979.

CEDAR CREST INN

An outstanding example of the Queen Anne style of architecture, Cedar Crest Victorian Inn is an extraordinarily detailed two-and-a-half-story mansion with twenty rooms. Built for Confederate veteran and local banker William E. Breese in 1891, it is located at 674 Biltmore Avenue.

The front façade is dominated by a turreted entrance bay. The pyramidal tower roof includes four steep gable dormers inset with small windows. The single-door main entrance on the first story contains a surround of sidelights and transom. To shelter this entrance, the architect installed an overhanging second-story porch. It features a shed roof with diagonal brackets and a decorative frieze, along with a turned balustrade. A shed roof with similar diagonal bracing protects the porch. Windows are double-hung and segmentally arched, with hood moldings and one-over-one lights.

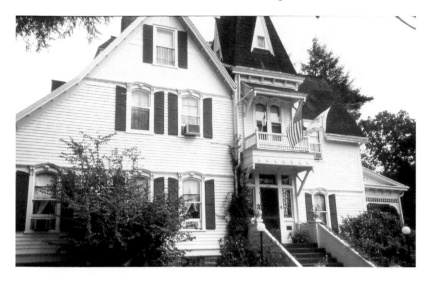

The double-gable side elevation includes a first-floor porch supported by free-standing uncoursed stone piers. Detailing of the porch includes post brackets, a spindle frieze, turned balusters and cornice brackets. Between the stone piers, similar brackets, spindles and balusters are installed. The porch continues around to the back with similar detailing.

Breese was thirty-seven when he founded the First National Bank of Asheville in 1885. The bank experienced a financial downturn in 1897 and was forced to close, with Breese being convicted of embezzlement and conspiracy to violate banking statutes. The charges were overturned in 1906, but Breese's reputation was ruined, forcing him to relocate to Brevard.

In 1902, Arthur Rees, general manager of the Hans Rees & Sons Tannery, purchased the property for $7,500 and named the house Kenilworth Lodge.

The house changed hands frequently, becoming a private residence, a tuberculosis sanitarium and a boardinghouse. The sanitarium operated from 1927 until 1932 under the name of Sherwood Sanitarium. In the mid-1930s, the house was purchased by John and Minnie Page, who operated it as a tourist home, renaming it Cedar Crest. Upon John's death in 1939, Minnie continued to operate the house until her death in 1976 at the age of ninety-five. The house continued in operation under the supervision of her daughters.

In 1984, new owners restored the property to its original opulence, creating one of Asheville's first bed-and-breakfast inns. Today, Cedar Crest remains one of the premier locations for creating a nostalgic glimpse into the society of the luxurious 1890s.

The building was placed on the National Register of Historic Places in 1980.

KENILWORTH INN APARTMENTS

Kenilworth Inn Apartments are located on Caledonia Road in the sprawling Asheville neighborhood of Kenilworth. The inn was built in 1918 under the financial guidance of James "Jake" Chiles and the architectural direction of Ronald Greene. Conceived in the Tudor Revival style popular from 1890 until the 1940s, the massive, asymmetrical, multi-wing structure is constructed of stucco over hollow clay tiles supported by a heavy timber frame. The four-story wings radiate from a five-and-a-half-story central block, with brick quoining applied to its corners and windows.

Dormers on each wing extend from a red-shingled gabled roof, varying from straight gable to hipped gable. Colorful half-timbering is applied to all gables.

Windows vary in size and configuration, with sashes from six-over-one to eight-over-one. A standing-seam copper shed roof carries across the front of the main façade. The grand entrance is dominated by a quarry-faced granite porte-cochere with beaded mortar joints.

The building's predecessor, the 1891 Kenilworth Inn, one of the earliest resort hotels, was a rambling Tudor-style frame structure also located in Kenilworth. The inn was extremely successful until 1909, when it was destroyed by fire. Lack of insurance prevented rebuilding the inn, and the 151-acre property was sold to Jake Chiles and the Kenilworth Park Company.

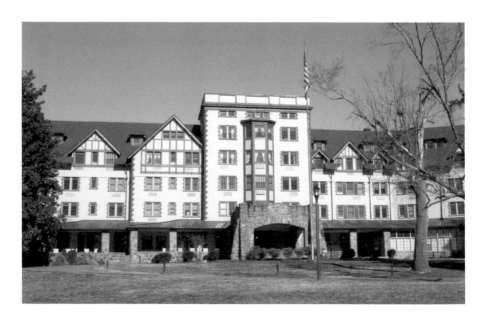

In 1913, the town of Kenilworth was incorporated, and Chiles was elected its first mayor—a position he would hold until 1923. Chiles also incorporated the Kenilworth Development Company as a real estate venture.

As tourism flourished, Chiles, an astute businessman who saw the economic potential of rebuilding the inn, hired architect Ronald Greene. Working with Carolina Wood Products (CWP) as the principal construction company, Chiles agreed to issue bonds with a lien on the property in return for CWP assuming total financing for the project. With the onset of the Depression and the closing of Asheville banks, Chiles was eventually forced into bankruptcy.

Construction of the Kenilworth Inn ran from 1916 until 1918. When the United States entered World War I in 1917, the U.S. Army leased the inn as General Hospital No. 12. During the war, eighteen German national internees who were being held at Hot Springs, North Carolina, contracted typhoid and were sent to Kenilworth for treatment, where they died. They are now buried in Riverside Cemetery.

The U.S. Army vacated the premises in 1919, and extensive renovation was required to return the inn to its prewar status. It was not until 1923 that the inn finally opened as a luxury resort hotel, and it remained successful until 1929, when economic difficulties due to the Great Depression forced the business into bankruptcy. The inn remained closed until 1931, when Dr. W.R. Griffin Sr. and Dr. Mark Griffin purchased the facility and converted it into a mental health facility called Appalachian Hall.

Following America's entry into World War II, the building was again used for military purposes when it became a U.S. Navy Convalescent Hospital. Appalachian Hall temporarily moved to the Princess Anne Hotel and the Forest Hill Inn. After the war, Appalachian Hall reoccupied the building and continued services until the 1980s, when Magellan Enterprises, a real estate holding company, purchased the property. Charter Behavioral Health Systems took over in 1994, only to sell six years later to E.F. Howington Company. Major renovations have now transformed the building into an apartment complex while maintaining the historical integrity of the building.

The building was placed on the National Register of Historic Places in 2001.

ASHEVILLE HIGH SCHOOL

Rising above McDowell Street on a well-terraced lawn is a monumental tribute to the artistry and avant-garde planning of Douglas Ellington. Combining elements of Art Deco and Italian Renaissance styles, Ellington

Aerial view showing Ellington's innovative Y pattern design. *Courtesy of the North Carolina Collection, Pack Memorial Public Library, Asheville, North Carolina.*

created one of the most beautiful and unusual high school designs in America. Radiating from a central hexagonal tower are three wings, each three stories high, branching out into a Y pattern, in which one wing houses a cafeteria and an auditorium, while the other two are academic wings that terminate respectively in a gymnasium and a science building.

The main building material is quarry-faced Balfour pink granite, which is laid in random shades. Belgian block paving stones of the same material are utilized for the spandrels. The central tower, with an ogee cap—or S curve—features bands of tan Airedale brick interspersed with rust-colored terra cotta flue linings for contrast. The seal of Asheville, located on the tower, uses brightly colored tiles, while the lighting fixtures and grilles are a natural finish.

The initial building was designed with sixty academic rooms for a student body of two thousand. The heating plant, located on McDowell Street, provides steam heat for the building. Built at a cost of over $1 million, the school opened in September 1929 with the name Asheville Senior High School. Due to economic restraints caused by the Great Depression, the school was temporarily vacated in 1933. Students were sent to David Millard and Hall Fletcher Junior Highs but returned the following year to Asheville High. In 1935, upon the death of Principal Lee H. Edwards, the school was renamed in his honor.

In 1969, integration brought about the merger of South French Broad High School (formerly Stephens-Lee High School) and Lee Edwards High School at the McDowell Street location. The newly merged school was named Asheville High School.

Over the years, Asheville High's campus has seen dramatic additions: a vocational building (1969), a gymnasium (1973), a media center (1974), a football stadium (1983), an arts building (1992), a new artificial playing surface for football (2005) and, in 2006, a cafeteria. Asheville High School was listed on the National Register of Historic Places in 1996.

Asheville High School was the fourth high school built in the city. David Millard High School (now demolished), located at the corner and Oak and College Streets, was the first in 1919, followed by Stephens-Lee (now demolished) in 1922. Hall Fletcher High School, in West Asheville, came along in 1925 and, finally, Asheville Senior High School in 1929. Upon completion of Asheville Senior High, David Millard and Hall Fletcher became junior high schools.

Stephens-Lee High School was a prominent African American school built in 1922. Upon completion of a new high school in 1965 on South French Broad Avenue, Stephens-Lee students relocated to South French Broad High School, and the old Stephens-Lee building became obsolete. When Asheville city schools integrated in 1969, Lee Edwards High School, on McDowell Street, and South French Broad High School combined to form Asheville High School at the McDowell Street site. South French Broad High School now became Asheville Junior High, and several years later, when the ninth grade moved to the high school, it became Asheville Middle School. Stephens-Lee High School was eventually torn down, except for the gymnasium, which is in use today by the Asheville Parks and Recreation Department for community programs.

The first school building constructed specifically for the African American community was built in 1892 at the corner of Catholic Avenue and Valley Street. Built as a three-story brick structure and named Catholic Hill School, it was the scene of a terrible tragedy in 1917 when seven children lost their lives in a raging fire. Education continued for the surviving students when suitable accommodations were found at four other locations. The school remained closed until a bond issue in 1922 provided for the construction of a new school at the same location. The new school was named Stephens-Lee in honor of Asheville's first African American principal, Edward Stephens, and Hester Lee, deceased wife of Walter S. Lee, principal of Catholic Hill School from 1910 until 1922. The new building contained nineteen classrooms and eleven grades. Ronald Greene was the architect.

THE CATHEDRAL OF ALL SOULS

George W. Vanderbilt, with his mother, Mrs. William K. Vanderbilt, visited Asheville during 1888 to consult with the well-known physician Dr. Westray Battle concerning Mrs. Vanderbilt's chronic bouts of malaria. While in Asheville, George and his mother stayed at the prestigious Battery Park Hotel, and it was here that George first observed the rich natural beauty of the area. Through an agent, Vanderbilt began buying up large tracts of land with the idea of building a hunting lodge and retreat. Richard Morris Hunt, the designer of several Vanderbilt mansions, was hired as the building's architect, with Frederick Law Olmsted as the landscape architect.

At Hunt's urging, plans for the house were quickly enlarged into a grand French Renaissance chateau, with construction beginning in 1889. To complement this vast building enterprise, Vanderbilt felt it was necessary to create a manorial village for the lodging of servants and estate workers and then eventually construct elaborate cottages for rental purposes. To this end, he purchased the small town of Asheville Junction (also known as Best), moved the inhabitants, razed the existing structures and constructed several temporary buildings. Following plans by Hunt and Olmsted, the streets were laid out in a fan shape, featuring four original buildings planned by Hunt. All Souls Episcopal Church was located at the apex of the fan, with the railroad station at the tip. An estate office building and parish hall completed the layout.

Designed in Romanesque style, All Souls Episcopal Church and Parish Hall were consecrated in 1896. The main part of the church resides under

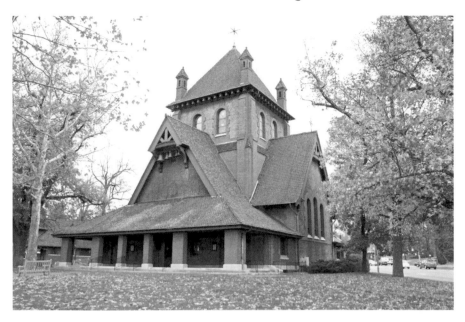

a square tower with a pyramidal roof and buttresses supporting each corner. Gable projections, with half-timbered framing, pebbledash finish and tile roofing, protrude from three sides of the tower. The fourth side of the church contains the circular apse and connects to an octagonal building used as a choir room. The church plan is in the Greek cross form, creating nave and transepts of equal length.

In the early 1950s, Swan Street, which originally connected to Hendersonville Road, was closed in order for the Parish Hall to be extended. The addition of a one-story education wing connected to the church was designed by Asheville architect William Waldo Dodge and completed in 1954.

The one-and-a-half-story Parish Hall, similar in style to the church, is notable for its wall dormers containing wide gables with trefoil trim and large supporting brackets. Four leaded-glass windows divided by muntins in the shape of a cross complete the dramatic effect.

The Cathedral of All Souls became the Cathedral of the Episcopal Diocese of Western North Carolina on January 1, 1995. The church was placed on the National Register of Historic Places in 1979.

After graduating from New York's Bellevue Hospital Medical College in 1875, Dr. Samuel Westray Battle enlisted in the United States Navy and was commissioned as an assistant surgeon, in which capacity he served until his retirement in 1884. Arriving in Asheville in 1885, Dr. Battle quickly

established a thriving practice with an emphasis on pulmonary afflictions, thus coming to the attention of Mrs. Vanderbilt.

In addition to his duties as chief of the medical staff at Mission Hospital, Battle also served as medical director of the Clarence Barker Memorial Hospital and Dispensary in Biltmore Village. The ten-bed unit, created by George Vanderbilt to honor his deceased cousin, was designed by Richard Sharp Smith. Asheville architect William Henry Lord added a 1902 addition, followed by another in 1916. In 1930, Douglas Ellington added a four-story, sixty-five-bed addition appropriately named the Battle Wing. In 1947, the hospital, then known as Biltmore Hospital, merged with Mission Hospital to serve as its maternity unit. The Imperial Life Insurance Co. purchased the property in 1951. The hospital's patients were transferred to the Victoria Hospital building, which had merged with Mission Hospital in 1950. Condominiums now occupy the building.

Dr. Battle died in 1927 at the age of seventy-three and is buried in Riverside Cemetery.

SAMUEL HARRISON REED HOUSE—BILTMORE VILLAGE INN

With all the grace and charm of a regal monarch overlooking her domain, this breathtakingly beautiful Queen Anne composition is an excellent example of the prominent style that captured this country from the 1870s to 1910. The house, dressed in sparkling white with blue trim and built by Samuel Harrison Reed, is located at 119 Dodge Street, where it sits on a magnificent hillside overlooking fashionable Biltmore Village. The two-story, highly ornate structure, built in 1892, is highlighted by a fully developed octagonal tower capped by an ogee roof. Three sides feature semi-octagonal bays surmounted by gables, within which a scalloped lunette is incised with a starburst pattern, a motif indicative of the Queen Anne style. A wide veranda wraps around to the east supported by turned and tapered porch posts under ornate brackets. A one-story pedimented portico extends from the main porch entrance with ornate scrollwork contained within the tympanum. Weatherboard siding abounds throughout, while a heavily molded multilayered cornice wraps around the building.

Samuel Harrison Reed, a prominent Asheville lawyer, constructed his house on Reed Hill overlooking the town of Best, which had been created by his father, Joseph, from his abundant landholdings. With the arrival

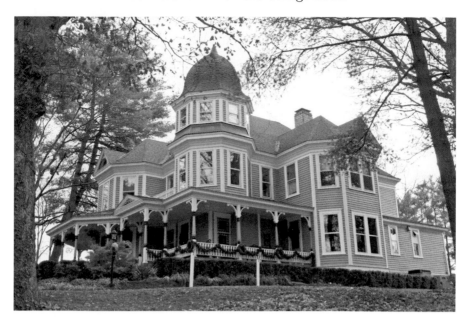

of George Vanderbilt, Samuel sold the town and hundreds of acres to Vanderbilt for the creation of his manorial village, renamed Biltmore Village. With Samuel's death in 1905, the remaining property was inherited by his only son, Charles Wingate.

The house and seventeen acres were sold by Charles in 1914 to a development company that subdivided the area for residential purposes. The house changed hands several times over the years. At one point, it became an apartment complex and then lay vacant for long periods. In 1973, it was purchased with the intention of maintaining it as a bed-and-breakfast. Following years of renovation, the house opened on a seasonal basis in 1985 as the Reed House. It continued in operation until being sold in 2000.

Now known as the Biltmore Village Inn, the grand lady over one hundred years old has been restored to her original beauty and maintains her place as one of the loveliest examples of Queen Anne architecture in Asheville.

BILTMORE HOUSE AND GARDENS

George W. Vanderbilt and his mother visited Asheville during 1888 to consult with Dr. Westray Battle concerning Mrs. Vanderbilt's chronic bouts of malaria. While in Asheville, George and his mother stayed at the prestigious Battery Park Hotel, and it was here that George was first able to

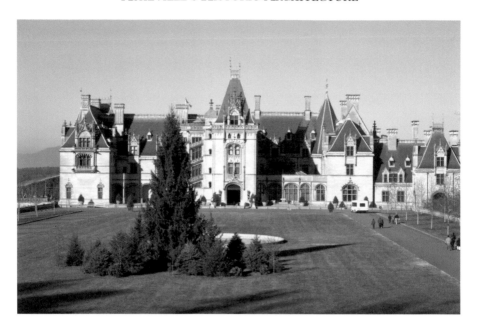

observe the rich natural beauty of the area. Through an agent, Vanderbilt purchased about 120,000 acres of land adjacent to Asheville with the idea of building a hunting lodge and retreat. Richard Morris Hunt was hired as the building's architect, Frederick Law Olmsted as the landscape architect and Karl Theodore Francis Bitter as the sculptor.

Vanderbilt, the youngest of eight children born to William Henry and Maria Louisa Kassam Vanderbilt, was quickly persuaded by Hunt to construct a four-story chateau in the French Renaissance style reminiscent of those in the Loire Valley of France. The design was for a 250-room mansion built of brick, Indiana limestone and Italian marble that would house the latest in technology and amenities, including electricity, a central heating system, elevators, telephones, refrigeration units, a synchronized clock system, an indoor swimming pool, a bowling alley and a gymnasium. The name "Biltmore" derives from the Dutch town of Bildt and the English word "more," meaning an open rolling landscape. A three-mile railroad spur was built from Biltmore Village to transport men and materials to the building site; in addition, an on-site brick kiln and woodworking factory were constructed. Construction began in 1889 with a workforce of approximately one thousand. A manual laborer, working a ten-hour day, six days a week, was paid $1.00 per day. At the top of the pay scale were the highly skilled stonecutters, making $3.50 per day. To ensure an efficient work flow, the entire construction project was organized under estate manager

Charles McNamee, who divided his men and materials into the following specialized departments: Asheville Woodworking, Brick and Tile Works, Forestry, Landscape, Engineering, Quarry, Agriculture and Architect (under Richard Sharp Smith). To ensure a completely fireproof structure, Hunt designed the walls to be of brick covered with a six-inch limestone veneer, with slate roofs supported by steel frameworks. Although construction was still incomplete, the house was opened to family and friends for a Christmas celebration in 1895.

Vanderbilt's goal was to create a working farm that would be self-sustaining in producing all necessary provisions for the estate; surplus items would then be sold to the local community. Seeking to establish an on-site dairy, Vanderbilt moved a large Jersey herd from Homestead, his Staten Island estate, to Biltmore in 1896. The dairy was quickly expanded into a highly successful commercial operation that would eventually expand into major areas of the Southeast. The dairy ceased operation in 1985 when it was purchased by Pet, Inc.

Interest in forestry conservation led Vanderbilt to hire Gifford Pinchot, thus creating America's first in-depth study of the effects of controlled growth. Following in Pinchot's footsteps was German-born Carl Schenck, who was instrumental in creating, in 1898, the Biltmore Forest School— known as the cradle of forestry—for the education of those interested in adapting scientific methods to America's forests.

In 1898, Vanderbilt married Edith Stuyvesant Dresser, a direct descendant of Peter Stuyvesant, Dutch governor of New Amsterdam (New York). Cornelia, their only child, was born in 1900 at the estate. In 1905, the Vanderbilts were instrumental in providing funding and encouragement to create Biltmore Estate Industries, a cottage industry that taught woodcarving, basket weaving, furniture making and weaving of homespun cloth to children of Biltmore Village.

With the death of George in 1914, following complications from an appendectomy operation, financial constraints required Edith to sell approximately 80,000 acres to the federal government in 1915, thus creating the nucleus of Pisgah National Forest. Biltmore Estate Industries was sold in 1917 to Fred Seely, who renamed it Biltmore Industries and moved the enterprise to newly constructed buildings adjacent to the Grove Park Inn. About 1,500 acres located next to Hendersonville Road was sold in 1920 to the newly formed Biltmore Estate Company for the purpose of developing homesites and would be chartered in 1923 as the town of Biltmore Forest. In 1921, Biltmore Village was sold to

commercial developers, with the exception of the estate office building, All Souls Church and the Clarence Barker Hospital, a ten-bed unit built by Vanderbilt to honor his deceased cousin.

Cornelia was married in 1924 to the Honorable John Francis Amherst Cecil, an English lord working for the British Embassy in Washington, D.C. Two sons were born to them: George Henry Vanderbilt Cecil in 1925 and William Amherst Vanderbilt Cecil in 1928. Each was to have considerable effect on the future success of the Biltmore Estate. In 1929, title to the property was transferred to Cornelia, who, working with legal advisor and trusted friend Junius Adams, effected transfer of the property to a new corporation called the Biltmore Company.

In 1930, the chateau was opened to the public as a source of much-needed income and to publicize the Asheville area. The first-year attendance numbered approximately forty thousand. With the breakup of the Cecils' marriage in 1934, Cornelia resided with the children in Europe while John took up residence at the estate. Adams was appointed president of the Biltmore Company and would remain in this position until his death in 1962. Daily operations were supervised by Chauncey Beadle, who came to Biltmore in 1890 to work under the direction of Olmsted. Beadle would continue employment at the house until his death in 1950.

The house remained open until the end of 1942, when it was closed for the duration of the war. In 1942, the National Gallery of Art, looking for a safe location for its many paintings and sculptures, selected the Biltmore House's unfinished Music Room for storage. The works would remain there until 1944. The house reopened in 1946 with forty-two thousand visitors paying two dollars per person, marking the first time that income exceeded expenses. The house continued with limited success until 1959, when William Cecil returned from a successful banking career to assume control of the house and grounds. Seeking to increase attendance, an updated advertising program was quickly instituted, followed by the total refurbishing of the Music Room and the adjoining Salon. Other improvements included the opening of more rooms, the institution of a wine operation, the opening of Deerpark Restaurant in a refurbished dairy barn and the construction of a new winery building in 1985.

The Biltmore Estate was officially divided in 1979, when the house and eight thousand acres became the property of William Cecil; the Biltmore Dairy, four thousand acres and numerous lots available for sale in the town of Biltmore Forest became the property of George Cecil.

The grandeur of Biltmore Estate has always been a major attraction for Hollywood and the movie industry. The following movies have used the estate as filming locations: *Tap Roots* (1949), *The Swan* (1955), *Being There* (1979), *Private Eyes* (1980), *Richie Rich* (1994), *Last of the Mohicans* (1992), and *My Fellow Americans* (1996).

Today, the house is one of America's major attractions and is the largest private residence in America.

Born in Brattleboro, Vermont, to a highly successful banker and politician, Richard Morris Hunt was the first American to attend the École des Beaux-Arts in Paris, France. From his return to America in 1855 until his death in 1895 at the age of sixty-six, he was the preeminent architect of his time and designed many of the major residential mansions for the socially elite in New York, Chicago and Newport, Rhode Island. In addition to Biltmore House, Hunt completed the following commissions for the Vanderbilt families: Idle Hour, for William K. on Long Island, in 1899; 660 Fifth Avenue, New York, for William K. in 1882, where the French Renaissance style was introduced to America; the Vanderbilt Mausoleum on Long Island in 1889; Marble House for William K. and Alva in Newport, Rhode Island, in 1892; and, in 1895, the Breakers for Cornelius II in Newport, Rhode Island.

Other notable structures designed by Hunt were the Statue of Liberty pedestal and base in 1885; the Administration Building for the 1893 World's Columbian Exposition in Chicago; the Fifth Avenue façade for the Metropolitan Museum of Art in 1895 (completed by his son Richard Howland Hunt in 1902); Ochre Court for Ogden Goelet in Newport, Rhode Island, in 1892; and the double mansion for Mrs. William Astor and son John Jacob Astor IV on New York's Fifth Avenue in 1895.

Frederick Law Olmsted, long considered to be the founder of American landscape architecture and creator of many of America's most prestigious and enduring park systems, was born in Hartford, Connecticut, in 1822. Following a varied career as dry goods merchant, seaman, farmer, writer, newspaper correspondent and publisher, Olmsted was hired as superintendent of New York's newly established Central Park. Working with Calvert Vaux, they were successful in obtaining the commission for the overall design of Central Park. After a short stint as executive director of the United States Sanitary Commission, which administered aid to Union soldiers during the Civil War, and a failed attempt with a California gold mining concern, he returned to New York to work with Vaux on Brooklyn's Prospect Park. Major

park designs quickly followed for cities such as Chicago, Buffalo, Niagara Falls and Boston and for the 1893 World's Columbian Exposition.

Biltmore Estate was to be his final project, as declining health forced Olmsted into retirement. He died in 1903.

Born in Vienna, Austria, in 1867, Karl Bitter immigrated to America in 1889 and quickly found work with Richard Morris Hunt executing architectural sculptures for the Marble House and groups of allegorical figures for the World's Columbian Exposition's Administration Building, Ochre Court, the Astors' double mansion, the Breakers and the Fifth Avenue façade of the Metropolitan Museum of Art. So impressive was his work that he was appointed director of sculptures for the 1901 Pan-American Exposition held in Buffalo, New York. His work for the Biltmore House included statues of Joan of Arc and St. Louis on the front façade's stair tower, the Winter Garden's *Boy Stealing the Geese*, the Banquet Hall's *Return of the Chase* over the fireplace and the *Contest of the Minstrels* below the organ gallery. In 1915, Bitters's life was tragically cut short when he was struck by an automobile and killed.

Brickwork Patterns

English bond: A pattern that alternates a row (course) of headers with a row of stretchers. The headers are placed in the center of a stretcher.

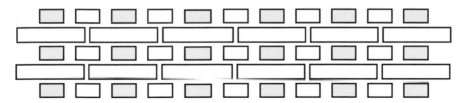

Locations: Interchange Building.

Flemish bond or Dutch bond: A pattern created by alternating a stretcher with a header along the same row or course. When the next course is laid, the header is placed in the middle of the stretcher below.

Locations: Asheville Savings Bank, Kress Building, Westall Building, Mount Zion Missionary Baptist Church, the Basilica of St. Lawrence, Smith-McDowell House.

American bond or common bond: A pattern with a row of headers followed with a varying numbers of stretcher courses; will usually be three, five, six or seven.

Locations: Asheville Savings Bank, First Presbyterian Church, Ravenscroft, Mount Zion Missionary Baptist Church, Hopkins Chapel AME Zion Church, Public Service Building, Hanger Hall, St. Matthias Church.

Stretcher bond or running bond: A pattern consisting of only stretcher units. The topmost stretcher is laid with its middle on the joint of the course below.

Locations: Trinity Episcopal Church, Jackson Building, Mount Zion Missionary Baptist Church.

In-and-out: Headers and stretchers alternate vertically.

Location: Asheville Fire Station.

Glossary of
Architectural Terms

ACANTHUS: A leaf used as decoration on capitals of the Corinthian and Composite order.

ANTHEMION: Classical leaf-like ornament suggestive of a palm leaf. Frequently used by architect E.L. Tilton throughout his career. Applied to the cornice of the Asheville Art Museum.

APSE: A semicircular or polygonal section constructed at the end of a church; usually faces east.

ARCADE: Arches placed in a row and supported by circular columns or square piers.

ARCHITRAVE: A decorative molding placed around a door or window; also the lowest level of an entablature.

ARCHIVOLT: A decorative border placed around the top of an arch. Typically used in Richardson Romanesque.

ART DECO: A style of architecture using decorative elements composed of geometric shapes applied in low-relief patterns.

ART NOUVEAU: An ornate style of decoration typified by the use of free-flowing lines.

ASHLAR MASONRY: Smooth, rectangular stone blocks squared on all sides.

BALCONET: A small projection below a window representative of a balcony.

BALUSTER: A vertical support for a railing system.

BALUSTRADE: A row of balusters supporting a railing system.

BARGEBOARD: A wide board fastened to the edge of a gable roof. The invention of the scroll saw allowed boards to be ornately carved. Also called verge boards.

BARREL VAULT: A masonry tunnel having a semicircular roof.

BASKET ARCH: An arch whose flat elliptical shape is suggestive of a basket's handle.

BAS-RELIEF: Same as low relief.

BATTERED: A tapered vertical surface that is larger at the bottom.

BEAD AND REEL MOLDING: A series of oval or round discs alternating with vertical beads.

BEAUX ARTS STYLE: An architectural style that was prominent from the late 1880s into the 1930s. Normally seen in public buildings such as museums (Metropolitan Museum of Art, New York), railroad terminals (Grand Central Station, New York), city halls, libraries (New York Public Library) and academic buildings. The style derived from the teachings of the École des Beaux-Arts in Paris, France, which emphasized details from Greece and Rome. American architects Richard Morris Hunt, the first American to graduate from the École, followed by Charles McKim of the architectural firm of McKim, Mead & White, were instrumental in introducing this style to America. Both architects were influential in the grand design of the buildings for the 1893 World's Columbian Exposition in Chicago.

BELT COURSE: A horizontal band of masonry or wood that projects from the exterior wall of a building; usually placed at the level of an interior floor.

BELVEDERES: A rooftop structure that is open on the sides to provide a view. Also called a cupola.

BEZANT: Coin- or disc-shaped decorations.

BLIND ARCADE: A row of closed arches attached to a wall as a decorative feature.

BRACKET: An ornamental or structural support piece used mainly under eaves, cornices and the like. Frequently used on Victorian and Italianate buildings.

BRAZIER: A large metal pan or tray to hold burning charcoal or coal.

BUTTRESS: A masonry pier fastened to the outside of a wall to resist the outward thrust of the wall.

CABLE MOLDING: A molding with surface decoration representing the twisting strands of a rope. Also known as rope molding.

CARTOUCHE: A decorative element in the shape of an oval set from the wall surface and containing an inscription.

CASEMENT WINDOW: A rectangular window with hinges placed on the side to allow the full height of the window to swing outward.

CHAMFER: To remove the corners of a post equally on all sides, usually at forty-five degrees.

CHINESE CHIPPENDALE: Thomas Chippendale (1718–1779) was an English furniture designer who developed a latticework style reminiscent of Chinese motifs. When applied to balustrades, it featured geometric diagonal or rectilinear balusters.

CINQUEFOIL: An ornament containing five connected lobes or semicircles. The shape is based on the leaves of the cinquefoil plant.

CLAPBOARD SIDING: Narrow horizontal overlapping boards that cover the side of wooden frame structures. See weatherboards.

COFFERED CEILING: Recessed ceiling panels usually square or octagonal.

COLONIAL REVIVAL STYLE: A return to the architectural values utilized by the early settlers.

COMMERCIAL STYLE: An architectural style used for tall office buildings that utilized steel-frame construction. Buildings often conceived as the three parts of a classical column: the first two floors formed the base while the floors above for offices created the shaft of the column. The top floors, housing mechanical equipment, defined the capital.

COMPOSITE CAPITAL: A Roman-designed capital that utilizes elements from the Greek Corinthian and Ionic capitals.

CONSOLE: An ornamental support bracket shaped in the form of a scroll. Also called an ancon.

CORBELLING: A series of stone or brick projections from a wall; usually placed in the cornice area. Each layer projects outward from the one below.

CORINTHIAN COLUMN: A fluted column having a capital composed of acanthus leaves and small volutes.

CORNICE: The highest exterior section of a building containing ornamental moldings; also the highest part of an entablature.

COURSE: A row of brick, stone or ashlar laid horizontally and usually bonded with mortar.

CRENELLATED: A parapet containing a series of rectangular or square openings.

CRUCIFORM: In the shape of a cross. The Latin cross is characterized by the main aisle (nave) being longer than the side aisles (transepts).

CUSHION CAPITAL: A capital resembling a cushion depressed by a vertical weight. Typical of Norman architecture.

DENTIL MOLDING: A series of rectangular tooth-like ornamental projections.

DIAPERWORK: A repeated pattern of lozenges or diagonals used for decorative effect.

DIOCLETIAN WINDOW: A semicircular window divided into three lights by two vertical mullions. The middle window is usually wider and sometimes arched. Used in the Thermae of Diocletian in Rome, Italy.

DORIC COLUMN: Among the three orders of Greek architecture, this is the oldest and simplest, containing a fluted column, a plain capital and no base.

DORMER: A small window set vertically on a sloping roof and its associated structure.

DOUBLE-HUNG WINDOW: A vertical window with two sashes offset from one another and designed to be raised and lowered independently. Developed in England and utilized in America around 1700, replacing the more common casement window.

DOUBLE-LEAF: Hinged doors hung in pairs.

DOUBLE PILE: A house that is two rooms deep.

DUTCH DOOR: A door divided horizontally into upper and lower halves that can be opened and closed independently of each other.

DUTCH GAMBREL: A roof with two slopes on each side, with the lower slope being the steeper.

EASTLAKE DECORATION: Charles Eastlake (1836–1906) was an English designer noted for a style of decoration that included spindlework, bargeboards and pediments with ornate openings and ornamental brackets.

ECLECTIC: Application of the best designs from various historical sources.

ÉCOLE DES BEAUX-ARTS: Famous architectural design school located in Paris, France. Noted for its emphasis on the classical elements from ancient Greece and Rome. Birthplace of the Beaux Arts style of architecture. Noted American students were Richard Morris Hunt, Henry Hobson Richardson, Stanford White, Julia Morgan, Edward L. Tilton, Daniel Burnham and Charles F. McKim.

EGG AND DART MOLDING: A series of decorative moldings alternating from egg shapes to arrow or dart-like shapes.

ENGAGED COLUMNS: A column attached to a wall; usually decorative.

ENTABLATURE: A horizontal band located between a classical column and the roof and divided into three parts: architrave, frieze and cornice. The Doric, Ionic and Corinthian entablatures all vary in detail.

FAÇADE: The front face of a building.

FANLIGHT: A fan-shaped window placed over a door and containing decorative tracery.

FEDERAL STYLE: American style of architecture popular from about 1780 to 1820. Similar to the Georgian style but simpler and more delicate in detailing. Sometimes called the Adam style.

FESTOON: A decoration incorporating elements of flowers, fruit, leaves, etc. Same as swag.

FLEUR-DE-LIS: A stylized design representation of the lily. Royal coat of arms of France.

FLUTING: The vertical grooves cut into the shaft of a column.

FLYING BUTTRESS: An arched support or brace built between the wall of a building and a supporting column to bear some of the outward pressure of the weight of the roof.

FOLIATE: Stylized representation of leaves and plants.

FRETWORK: Decorative designs in an interlocking pattern placed in low relief.

FRIEZE: A horizontal band of masonry ornamented with sculptures or low-relief floral motifs. Also, the middle band of an entablature.

GAMBREL ROOF: A roof that has two slopes on each side, with the lower slope the steeper of the two. Typical for country barns.

GEORGIAN STYLE: From 1700 to 1780, this style was popular along the eastern seaboard and featured a highly symmetrical composition, often with a two-story

portico. Details included hip roof balustrades, end chimneys, corner quoins, keystone lintels and a Palladian window.

GOTHIC REVIVAL: A style of architecture in America from 1830 to 1880 made popular through the combined work of Andrew Jackson Downing and Alexander Jackson Davis in their many publications. Buildings are asymmetrical with steeply pitched roofs, pointed arch windows and decorated bargeboards. The more elaborate structures would contain turrets and battlements, with the best example, called Lyndhurst, being located in Tarrytown, New York.

GREEK REVIVAL STYLE: A style of architecture prominent from the 1820s into the 1860s. Buildings are typically symmetrical with front gabled pedimented portico. Use of the Doric and Ionic capitals was prevalent. The style, predominately painted white, was adopted for both residential and public buildings. The style became popular due to America's sympathy for Greece's fight for independence. Called the National style due to its overwhelming popularity.

GRIFFIN: In Greek mythology, a creature with the head, wings and forelegs of an eagle and the body, hind legs and tail of a lion.

GROIN VAULT: The intersection of two barrel vaults at right angles forming a ridge called a groin.

GUTTAE: One of a series of ornaments in the form of an inverted frustum of a cone.

HALF TIMBERING: Exterior framing left exposed as a decorative element. The space between the members filled with various materials, such as brick, pebbledash, etc.

HEADER: The end of a brick exposed to the exterior wall.

HEART AND DART: A decoration consisting of alternating stylized hearts and darts. Also called leaf and dart.

HOOD MOLDING: A molding that projects over a door or window to divert rainwater.

IMBRECATION: The overlapping of tiles or shingles to resemble fish scales. Common in the Queen Anne style.

IMPOST: The decorative unit placed at the end of an arch that receives and distributes the weight of the arch.

IONIC COLUMN: A Greek column with a capital composed of volutes.

ITALIANATE STYLE: A style of American architecture from 1840 to 1890 that was made popular by author Andrew Jackson Downing's *Victorian Cottage Residences*. Buildings are usually two or three stories tall and rectangular in plan. Intricately carved brackets, often in pairs, support wide overhanging eaves. Windows are tall with hood moldings surmounted by flat or hipped roofs.

JEFFERSONIAN CLASSICISM: Classical style of architecture that Thomas Jefferson (1743–1826) promoted for construction of new buildings after the Revolution. His

personal designs were for the Virginia State Capitol in Richmond, Virginia, the University of Virginia at Charlottesville, Virginia, and his Monticello residence near Charlottesville, Virginia.

JERKINHEAD: A gable roof angled at the corner to create a mini hip configuration.

KEYSTONE: The centerpiece of an arch, usually larger and wedge shaped.

LANCET WINDOW: A tall, narrow window topped by a sharply pointed arch. Prominent in Gothic architecture.

LEAF: A door with hinges.

LIGHT: Window glass.

LINTEL: A member placed horizontally over a door or window to support the weight of the wall above.

LOGGIA: An arcade that is open on one or both sides.

LOW RELIEF: Decorations that project slightly from a wall surface; also called bas-relief.

LUNETTE: Crescent-shaped or semicircular window.

MANSARD ROOF: A roof with two slopes on all four sides of the building. Designed by the French architect Francois Mansart. The lower slope is steep, with the top slope being nearly flat. The lower slope can be concave or convex.

MEDALLION: An ornamental design in bas-relief placed on a wall, ceiling or frieze and usually decorated with flowers, geometric shapes, etc.

METOPES: Panels placed between the triglyphs in the frieze of a Doric entablature. Panels can be plain or decorative.

MISSION-STYLE ROOF: A roof composed of red terra cotta tiles dating from the Spanish California missions.

MODILLION: A series of ornamental brackets or blocks used under a cornice.

MUNTIN: Support strips to hold panes of glass within a window frame.

MUTULE: A flat block projecting from under a Doric cornice.

NEOCLASSICAL: Designs based upon the principles of Greece and Rome.

PALLADIAN WINDOW: Tall, arched center window flanked by two shorter rectangular ones. Based upon the design of Andrea Palladio (1508–1580), noted Italian Renaissance architect. His most famous structure, the Villa Rotonda, set the standard for architectural design for Roman temple forms. Thomas Jefferson's Monticello was based on this building.

PARAPET: A low, decorative wall placed at the uppermost edge of a building.

PATERA: A round or oval ornament in bas-relief.

PAVILION: The part of a building offset from the rest of the building; usually placed in the center.

PEBBLEDASH: An exterior finish in which pebbles are embedded in the stucco base prior to hardening.

PEDIMENT: The triangular gable located at the end of a building. Any triangular or curved feature located over a door, window, etc.

PENDANTS: A decorative element, hanging from a roof or ceiling; usually carved or cast.

PENT ROOF: A short roof placed over a first-floor exterior door or window.

PERGOLA: An open latticework collection of wooden beams supported by posts.

PILASTER: A column or pier attached to a wall. Similar to an engaged column.

PINNACLES: A vertical ornament, usually tapered, placed above a roof, tower, etc.

PORTE-COCHERE: A covered entryway through which vehicles can drive; provides shelter for passengers entering and leaving.

PORTICO: An entrance porch, usually two stories tall, topped by a pedimented roof and supported by columns.

QUARRY-FACED: Rectangular masonry blocks with the rough face placed toward the exterior of a building.

QUEEN ANNE STYLE: American architectural style prominent from 1870 to 1910. Asymmetrical, with wide verandas, turret towers, gingerbread decoration, steeply pitched gable roofs and bargeboards.

QUOINS: Flat sections in brick or stone placed at the corners of buildings for emphasis.

RANDOM COURSED: Horizontal rows of stone laid in unequal heights.

REEDING: Convex moldings applied parallel to each other. The reverse of fluting.

RIBBON WINDOW: A horizontal row of windows placed side by side. Typical in Art Deco– and Prairie-style buildings.

RINCEAU: Decorative low-relief sculpture representing intertwining foliage.

ROCK-FACED: The rough or uneven face of a stone.

ROMAN ARCHED: A semicircular arch.

ROMANESQUE STYLE: Based on Roman and Byzantine elements, and popularized in this country by H.H. Richardson in the 1880s. Its massive use of rock-faced limestone made it suitable for churches, libraries, railroad terminals, large universities and courthouses. Typical building would be asymmetrical with rounded arches and steeply pitched hip roofs.

ROSETTES: Circular ornaments depicting roses or other floral motifs.

ROSE WINDOW: A circular window inset with tracery that radiates from the center.

RUSTICATION: Brick or stone courses set off by deeply set mortar joints.

SAILOR COURSE: Bricks laid vertically with the wider face exposed.

SALTBOX: A gable house with unequal roof lengths. The shorter side faces the front with the longer toward the rear.

SASH: The framework of a window.

SECOND EMPIRE STYLE: Popular in America from 1850 to 1890. Buildings were multistory structures utilized mainly for public or governmental usage and characterized by a mansard-style roof. Second Empire style is often called the

General Grant style due to the many public buildings constructed during his administration.

SEGMENTAL ARCH: A circular arch somewhat less than a semicircle.

SHINGLE STYLE: An American style of domestic architecture developed in the 1880s and attributed to H.H. Richardson (1838–1886) was based on the 1883 Stoughton House located in Cambridge, Massachusetts. A typical house would be two to three stories tall faced with shingles, giving it an overall appearance of uniformity.

SIDELIGHTS: Vertical rectangular windows flanking an entrance door.

SOLDIER COURSE: Bricks placed vertically with the narrow face exposed.

SPANDRELS: A decorative panel placed above and below windows; also, the triangular space between the arch of a door and its rectangular frame.

STRETCHER: A brick placed horizontally.

STRINGCOURSE: See belt course.

SURROUND: Decorative elements placed around a door or window.

TERRA COTTA: Brownish-red clay baked to a hard consistency. Latin for "cooked earth."

TRACERY: Muntins used in a decorative fashion to form geometric shapes.

TRANSOM: A rectangular window placed over a door. Can be fixed or movable.

TREFOIL: A three-lobed cloverleaf pattern.

TRIGLYPHS: The Vertical blocks on a Doric frieze that separates the metopes. Tryglyphs are composed of two V-shaped vertical grooves (glyphs) in the center with half-grooves at the edges.

TUSCAN COLUMN: A simplified version of the Roman Doric order, having unfluted columns, a simplified frieze and no triglyphs.

TYMPANUM: A triangular recessed area formed by a pediment.

UNCOURSED: Masonry laid in random courses.

VERANDA: A large porch, usually across the front and down one side.

VERGEBOARD: Same as barge board.

VOLUTE: A scroll-like ornament used in the Ionic capital.

VOUSSOIRS: The wedge-shaped masonry blocks that form an arch; the center block is called a keystone.

WATER TABLE: A masonry projection located between the foundation and the first floor to divert rainwater from the wall.

WEATHERBOARDS: Overlapping horizontal boards used to cover the exterior of a building. Can be wedge-shaped with the thicker along the lower edge.

ZIGGURAT: A stepped pyramid in which each step is smaller than the one below.

Source: Cyril M. Harris, *American Architecture: An Illustrated Encyclopedia* (New York: W.W. Norton & Co., 1998)

Bibliography

Bishir, Catherine, Michael Southern and Jennifer F. Martin. *A Guide to the Historic Architecture of Western North Carolina.* Chapel Hill: University of North Carolina Press, 1999.

Black, David, ed. *Historical Resources of Downtown Asheville North Carolina.* City of Asheville. Division of Archives & History. North Carolina Department of Cultural Resources, 1979.

Blackmun, Ora. *A Spire in the Mountains.* Asheville, NC: First Presbyterian Church, 1970.

Blumenson, John J.G. *Identifying American Architecture. A Pictorial Guide to Styles and Terms 1600–1945.* 2nd Ed. New York: W.W. Norton, 1981.

Bowers, Sybil Argintar. *Local Historic Property Designation Report for the National Bank of Commerce.* October 31, 2005.

———. *Local Historic Property Designation Report for Robert Sproul Carroll House 19 Zillicoa Street Asheville, North Carolina.* August 20, 2002.

Brower, Nancy. "Smith's Personal Style Matched His Drawing Board." *Asheville Citizen Times,* July 23, 1957.

Brown, George Carl. "History of Public Education in Asheville." Master's thesis, University of Maryland, 1940.

Brunk, Robert S., ed. *May We All Remember Well.* Vol. II. Asheville, NC: Robert S. Brunk Auction Services, Inc., 2001.

Bryan, John M. *Biltmore Estate.* New York: Rizzoli International Publications, Inc., 1994.

Coffin, Laurence E., and Beatriz de Winthuysen Coffin. "A Maryland 'New Town' Turns 50." *Landscape Architecture* (June 1988).

Covington, Howard E., Jr. *The Lady on the Hill.* Hoboken, NJ: John Wiley & Sons, Inc., 2006.

Davis, Lenwood. *Black Heritage of Western North Carolina.* Southern Highlands Research Center, University of North Carolina at Asheville, n.d.

Deweese, Charles W. *The Power of Freedom.* Franklin, TN: Providence House Publishers, 1997.

Dupre, Judith. *Skyscrapers.* New York: Black Dog & Leventhal Publishers, Inc., 1996.

Gaines, Henry Irven. *Kings Maelum.* New York: Vantage Press, 1972.

Gurley, Robert M. "Richard Sharp Smith." Master's thesis, University of South Carolina, 1994.

Harris, Cyril, ed. *American Architecture: An Illustrated Encyclopedia.* New York: W.W. Norton & Co., 1998.

———. *Dictionary of Architecture and Construction.* 4th ed. New York: McGraw Hill, 2006.

———. *Illustrated Dictionary of Historic Architecture.* New York: Dover Publications, Inc., 1977.

Historic Resources Commission of Asheville and Buncombe County. *An Architect and His Times: RICHARD SHARP SMITH.* Asheville, NC, 1995.

BIBLIOGRAPHY

Humphries, Carolyn. Private paper. November 1996.

Hurt, Barbara S. "Richard Morris Hunt & the Vanderbilts: Their Unique Contribution to American Architecture." Master's thesis, University of South Carolina, 1990.

Lord, Anthony, and Elizabeth Kostova. *1927 The Good-Natured Chronicle of a Journey*. Asheville, NC: Captain's Bookshelf, 1995.

Marlowe, Nancy. *The Legacy of Mission Hospitals*. Asheville, NC: Mission Hospitals, 2004.

Mathews, Jane Gianvito, and Richard A. Mathews. *The Manor & Cottages—Albemarle Park*. Asheville, NC: Albemarle Park Manor Grounds Association, Inc., 1991.

Montford Resource Center. *Historic Montford Neighborhood: Architectural Guide*. Asheville, NC, 2000.

Parks, Janet, and Alan G. Neumann, AIA. *The Old World Meets the New*. Avery Architectural & Fine Arts Library & the Miriam & Ira D. Wallach Art Gallery. Columbia University in the City of New York, 1996.

Preservation Society of Asheville & Buncombe County. *Historic Montford*. Asheville, NC, 1985.

Roth, Leland M. *A Concise History of American Architecture*. New York: Icon Editions, Harper & Row Publishers, 1979.

Sullivan, Louis. "The Tall Office Building Artistically Considered." *Lippincott's Magazine* 57, (March 1896): 403.

Swain, Douglas, ed. *Cabins & Castles. The History & Architecture of Buncombe County, North Carolina. City of Asheville, County of Buncombe*. Division of Archives and History, North Carolina Department of Cultural Resources, 1981.

Whiffen, Marcus. *American Architecture Since 1780*. Cambridge, MA: MIT Press, 1999.

INDEX